THE BEST OF
POTTERY

VOLUME TWO

First published in the United States of America by:
Quarry Books, an imprint of
Rockport Publishers, Inc.
33 Commercial Street
Gloucester, Massachusetts 01930-5089
Telephone: (978) 282-9590
Fax: (978) 283-2742

Distributed to the book trade and art trade in the United States by:
North Light, an imprint of
F & W Publications
1507 Dana Avenue
Cincinnati, Ohio 45207
Telephone: (800) 289-0963

Other Distribution by:
Rockport Publishers, Inc.
Gloucester, Massachusetts 01930-5089

ISBN 1-56496-446-9

10 9 8 7 6 5 4 3 2 1

Design: Lynn Pulsifer and Bill Dereeza for Spike's Halo
Design and Layout: Sawyer Design Associates, Inc.
Pottery on cover by: front (left): *Regis C. Brodie, p.70*
 (center) *Kathy Erteman, p.39*
 (right): *Winthrop Byers*, p.100
 front flap: *Mary T. Nicholson, p.97*
 back (left): *James C. Watkins*, p.44
 (center): *Paul A. Menchhofer, p.108*
 (right): *Yvonne Kleinveld, p.111*

THE BEST OF
POTTERY

selected by Angela Fina and Christopher Gustin
introduction by Christopher P. Staley

GLOUCESTER MASSACHUSETTS

QUARRY BOOKS

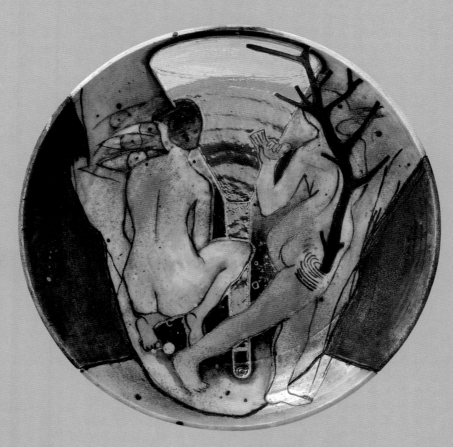

VOLUME TWO

CONTENTS

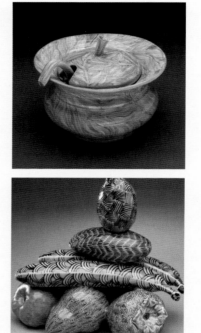
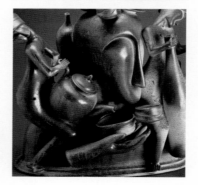

INTRODUCTION

A thousand years ago the Mimbres people not only dug graves for their parents but made truly remarkable pottery with painted imagery on the inside of the pots inspired by their way of life. Now what is the connection between digging graves and a book entitled *The Best of Pottery 2*? When the Mimbres buried their relatives, they would cover the faces of the dead with these exquisite bowl-shaped pots. The Mimbres would bury their dead a couple of feet below-ground in the same dwelling in which they slept and lived. Having had the opportunity to look at these pots, I have found that many of them touch me deeply. The reason I believe these pots are so powerful is because the Mimbres created them in an attempt to give meaning to their lives. This search for meaning is part of the human condition.

One of the activities inherent to being human is eating and drinking. This daily ritual I believe enables people to intrinsically relate to pottery. Thus, when the first edition of *The Best of Pottery* came out, the title immediately grabbed people's attention. The title is also provocative in that one wonders what criteria one would use to select *The Best of Pottery*. After looking through the book, some pottery connoisseurs were, I'm certain, most upset by the selections. This second *Best of Pottery* book is similar to the first in that it will be a book that potter pundits will love to hate.

The jurors, Angela Fina and Christopher Gustin, are both distinguished potters. They made their selections from over a thousand slide entries. Using this type of selection process to produce a book on the best of pottery inherently involves pluses and minuses. The drawback is that many quality potters did not submit slides and are thus not included in the book. The benefit is that readers do get to see a much wider spectrum of work than they would in a curated book. Consequently, I believe one of the strengths of this book is the wide range of aesthetic tastes represented among the selected pots. Thus, it is up to the viewers to decide for themselves which pots are banal and which are sublime.

For today's potter who lives in the midst of the most market-driven culture ever experienced, it can be a challenge to find that inner voice that speaks from the heart. To hear this voice from the heart, the potter needs to hear through the din of technology and mass media to that which truly gives meaning to their lives.

Despite the multitude of distractions that are a part of our time, there are potters who have created work that enriches our lives. Some of these potters are included in this book. For example, the colorful pots of Linda Arbuckle speak of her enthusiasm for flora and the service of food. The work of potter Mary Barringer speaks of her passion for history and perhaps a more contemplative time. The potter John Goodheart has created visually-charged pots by combining both clay and metal that serves to make them at the same time both unsettling and appealing. These pots, in addition to numerous others in this book, speak meaningfully to us because we sense in them the shared experience of life's texture and depth.

The late scholar, Joseph Campbell, wrote "when we quit thinking primarily about ourselves and our own self-preservation, we undergo a truly heroic transformation of consciousness." Perhaps this is the most we can ask for, that in a small yet significant way, *The Best of Pottery* helps us move beyond ourselves and makes our world a more thoughtful and reflective one.

CHRISTOPHER P. STALEY
HEAD OF CERAMIC ARTS DEPARTMENT
PENNSYLVANIA STATE UNIVERSITY

Mimbres Bowl

1,000 A.D.
Inspired by lightning bolts

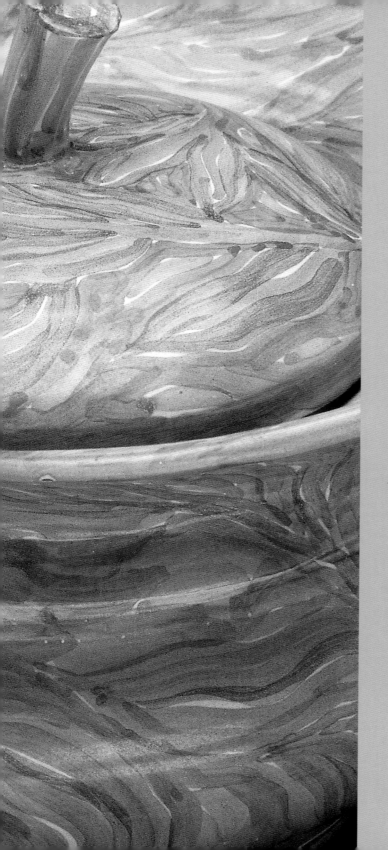

EARTHENWARE

The term "earthenware" describes
both clay composition and firing temperature.
Generally speaking, earthenware is a porous clay
body (without glass vitrification) fired at temperatures
ranging from cone 010 to cone 6. However, many potters fire
their work multiple times, using different temperatures for
clay, glazes, luster, and other embellishment. The pottery
that appears in this section was designated earthenware
by the contributing artists: the section title is
intended only in its broadest sense.

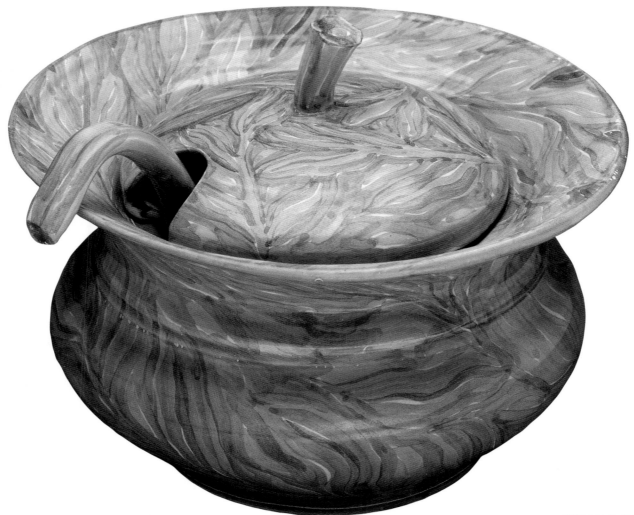

SUSAN SIPOS
Blush of Summer

Thrown earthenware
Glaze and Firing: Majolica glaze,
oxidation firing in an electric kiln

w 10.5 × h 9.5 × d 10.5 inches
w 27 × h 24 × d 27 centimeters

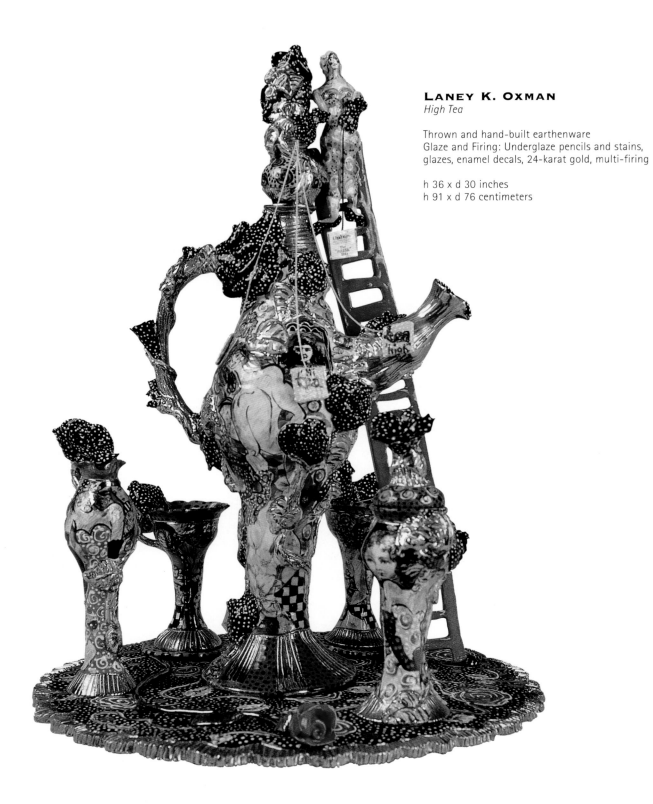

LANEY K. OXMAN
High Tea

Thrown and hand-built earthenware
Glaze and Firing: Underglaze pencils and stains,
glazes, enamel decals, 24-karat gold, multi-firing

h 36 x d 30 inches
h 91 x d 76 centimeters

SARA E. BRESSEM
Viennese Emperor

Hand-built earthenware
Glaze and Firing: Underglaze, oxides, cone 04
glazes, multi-firing in an electric kiln

w 6 × h 15 × d 4.5 inches
w 15 × h 38 × d 11 centimeters

UNA MJURKA
Untitled

Hand-built earthenware
Glaze and Firing: Underglazes, glaze,
low-fire oxidation firing

h 16-20 inches
h 41-51 centimeters

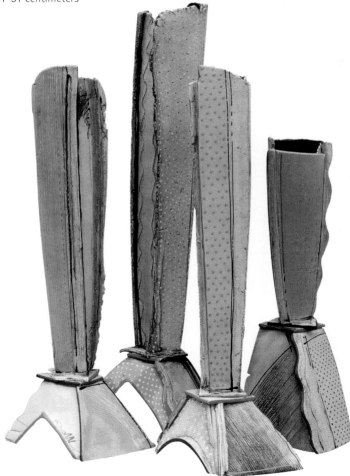

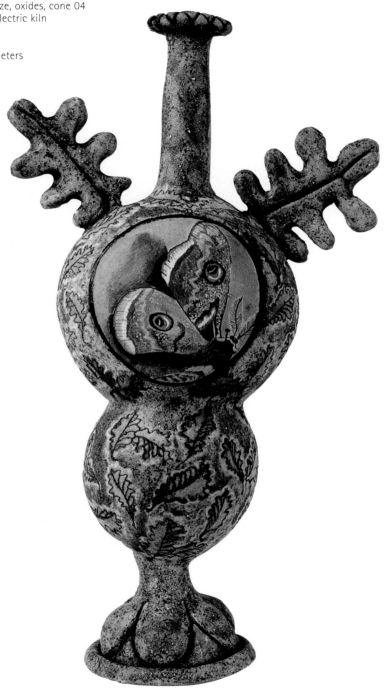

JAMES C. WATKINS
Knight/Night Bird

Thrown and hand-built earthenware
Glaze and Firing: Unglazed, terra sigillata, raku
glaze, sagger firing

w 28 × h 19 inches
w 71 × h 48 centimeters

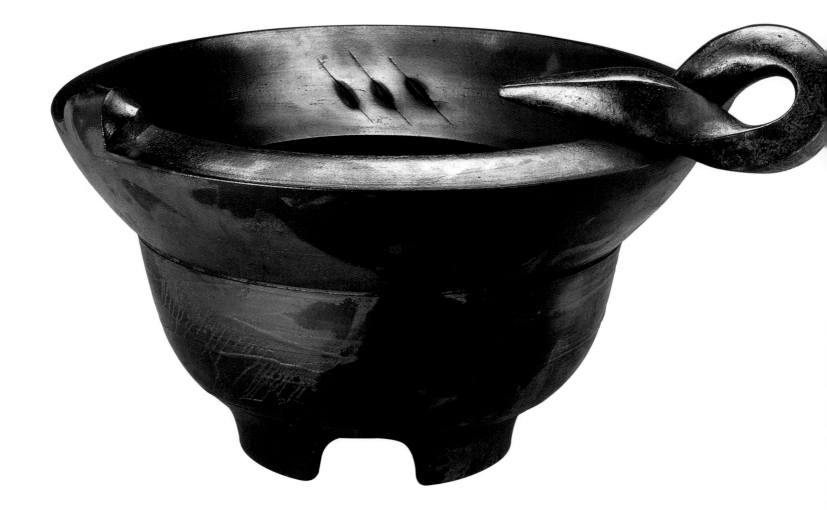

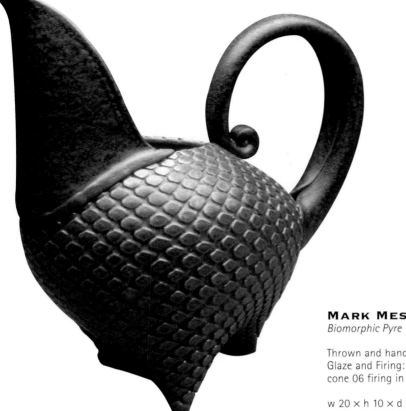

MARK MESSENGER
Biomorphic Pyre

Thrown and hand-built earthenware
Glaze and Firing: Low-fire cone 04 and
cone 06 firing in an electric kiln

w 20 × h 10 × d 9 inches
w 51 × h 25 × d 23 centimeters

SANDI PIERANTOZZI
Proud Bird

Slab-built earthenware
Glaze and Firing: Low-fire glaze, cone 04
bisque/cone 05 glaze, firing in an electric kiln

w 7 × h 8 × d 6 inches
w 18 × h 20 × d 15 centimeters

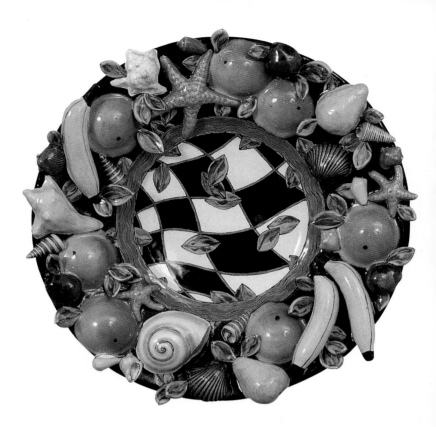

FARRADAY NEWSOME SREDL
Platter with Fruit and Seashells

Slab-formed earthenware with attached press-molded elements
Glaze and Firing: Brushed cone 05 glazes, firing in an electric kiln

w 25 × h 6 × d 25 inches
w 64 × h 15 × d 64 centimeters

HENRY CAVANAGH
Checker cab cookie jar

Slip-cast earthenware altered from original mold
Glaze and Firing: Stains, glazes, cone 04 bisque, cone 06 glaze, cone 019 luster firing

w 14 × h 9.5 × d 9 inches
w 36 × h 24 × d 23 centimeters

JUDITH SALOMON
Platter

Hand-built earthenware
Glaze and Firing: Cone 04 low-fire
oxidation firing in an electric kiln

w 20 × h 3 inches
w 51 × h 8 centimeters

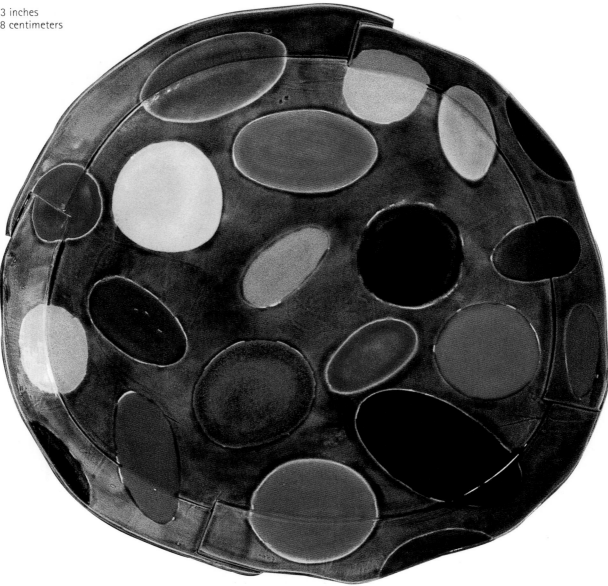

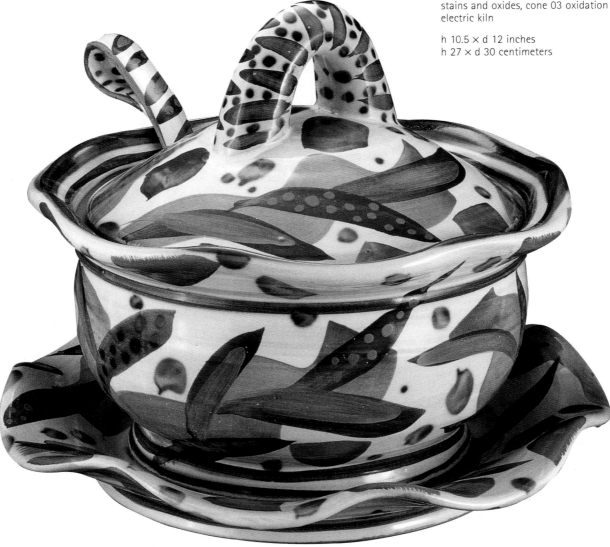

STANLEY MACE ANDERSEN
Tureen

Thrown and hand-built earthenware
Glaze and Firing: Opaque white glaze, brushed
stains and oxides, cone 03 oxidation firing in an
electric kiln

h 10.5 × d 12 inches
h 27 × d 30 centimeters

POSEY BACOPOULOS
Creamer and sugar set

Thrown, altered, and assembled earthenware
Glaze and Firing: Majolica glaze, stains,
cone 04 firing in an electric kiln

w 12 × h 5 × d 9.5 inches
w 30 × h 13 × d 24 centimeters

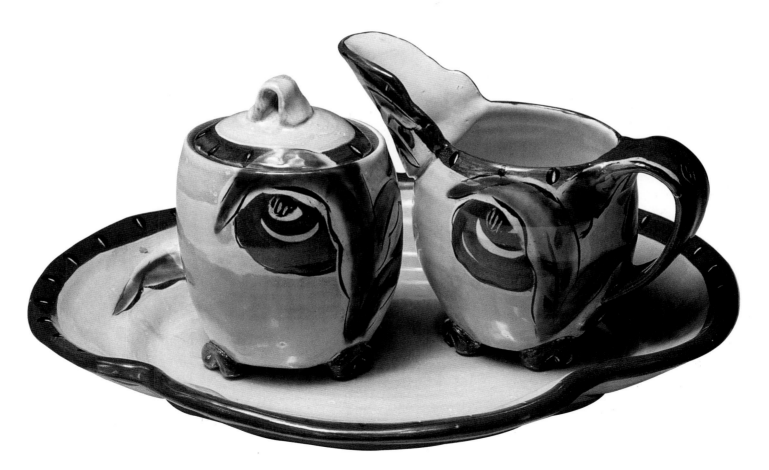

ANNA CALLOURI HOLCOMBE
Still Life Box VI

Hand-built earthenware
Glaze and Firing: Terra sigillata, underglazes,
low-fire glaze, cone 04 firing in an electric kiln

w 11 × h 21 × d 4 inches
w 28 × h 53 × d 10 centimeters

ERIC VAN EIMEREN
Ketchup-Mustard-Pickle-Relish

Press-molded, slip-cast, and hand-built
earthenware
Glaze and Firing: Cone 04 and cone
020 luster, oxidation firing

w 20.5 × h 14 × d 10.5 inches
w 52 × h 36 × d 27 centimeters

JANET LOWE
Worm bowl

Hand-built of extruded earthenware coils
Glaze and Firing: Clear low-fire glaze, oxidation
firing in an electric kiln

w 14 × h 14 inches
w 36 × h 36 centimeters

RICHARD SWANSON
He/She Teapots

Molded earthenware
Glaze and Firing: Sanded and polished clay
surface, cone 05 firing in an electric kiln

w 8.5 × h 6 × d 4 inches
w 22 × h 15 × d 10 centimeters

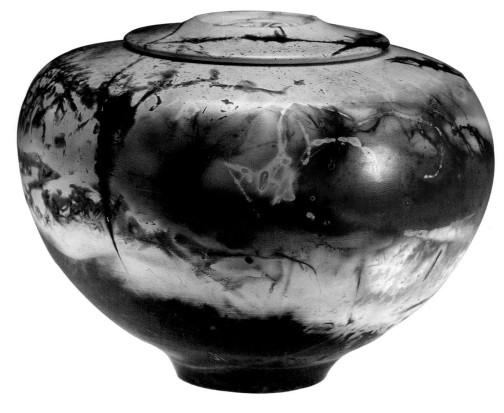

JUDY MOTZKIN
Spirit keeper with woven lid

Thrown earthenware with woven coil inlay
Glaze and Firing: Unglazed, terra sigillata
polished, and flame-painted with volatized
salts, metals, and combustibles, cone 06 gas
sagger firing

w 9 × h 9 × d 9 inches
w 23 × h 23 × d 23 centimeters

ROBERT L. WOOD
Paramphoric

Thrown and press-molded earthenware
Glaze and Firing: Stain and frit coloring, cone 01
firing in an electric kiln

w 32 × h 18 × d 14 inches
w 81 × h 46 × d 36 centimeters

BOB DIXON
Covered urn

Thrown and hand-built earthenware
Glaze and Firing: Majolica glaze, oxidation firing

w 20 × h 22 × d 22 inches
w 51 × h 56 × d 56 centimeters

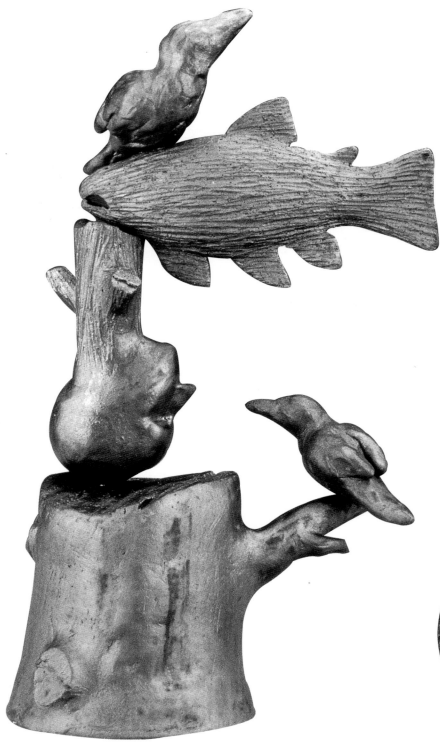

TED VOGEL
Black Stack Roost

Hand-built, carved, and press-molded earthenware
Glaze and Firing: Copper and black mason stain slip, cone 03 firing in an electric kiln

w 12 × h 21 × d 12 inches
w 30 × h 53 × d 30 centimeters

HARVEY SADOW
Jupiter Diary series

Thrown and hyperextended earthenware
Glaze and Firing: Eutectic slips/silaceous lacquers, multiple-raku firings

w 10.5 × h 13.5 × d 13.5 inches
w 27 × h 34 × d 34 centimeters

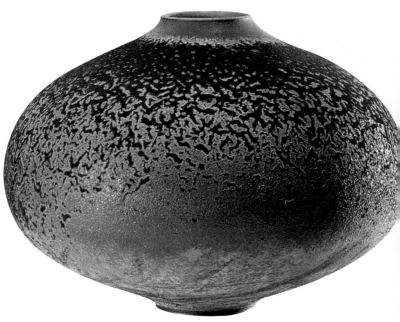

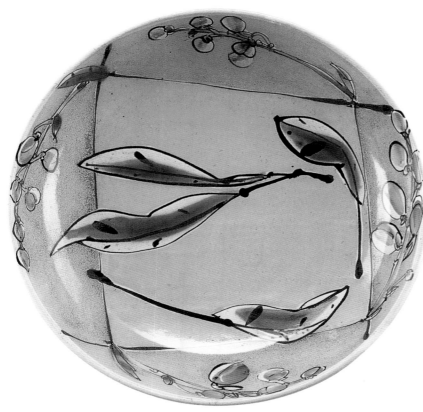

LINDA ARBUCKLE
Bowl: Berries

Thrown earthenware
Glaze and Firing: Majolica glazes,
oxidation firing in an electric kiln

h 2.5 × d 10 inches
h 6 × d 25 centimeters

NANCY GARDNER
Vase

Pinched and coil-built earthenware
Glaze and Firing: Underglazes, clear glaze,
cone 06 oxidation firing

w 18 × h 12 × d 5 inches
w 46 × h 30 × d 13 centimeters

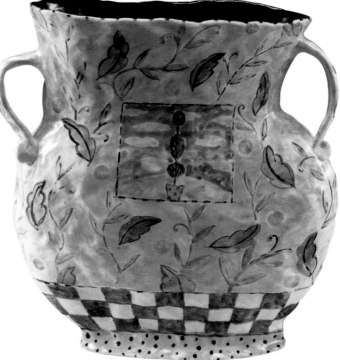

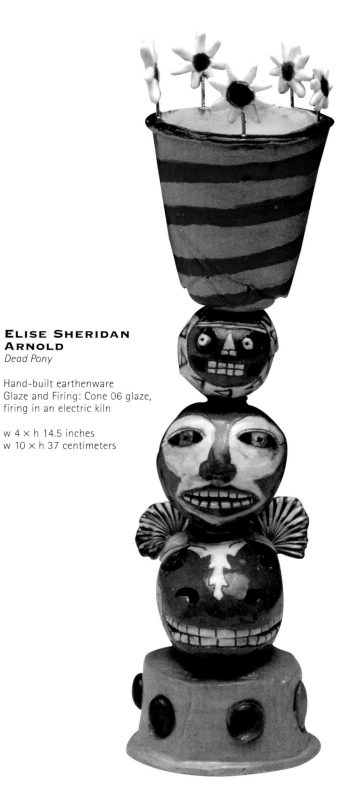

ELISE SHERIDAN ARNOLD
Dead Pony

Hand-built earthenware
Glaze and Firing: Cone 06 glaze,
firing in an electric kiln

w 4 × h 14.5 inches
w 10 × h 37 centimeters

FRANCINE OZEREKO
Still life

Press-molded earthenware
Glaze and Firing: Hand-painted, glazes, cone 04
firing in an electric kiln

w 14 × h 22 × d 2 inches
w 36 × h 56 × d 5 centimeters

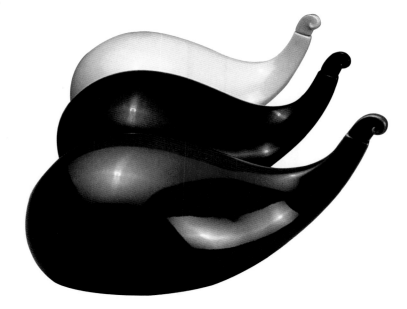

DAVID CALVIN HEAPS
Tear drop flasks with stoppers

Slip-cast earthenware
Glaze and Firing: White, black, and jade
glazes, oxidation firing at 300° F
per hour

w 9 × h 6 × d 4.5 inches
w 23 × h 15 × d 11 centimeters

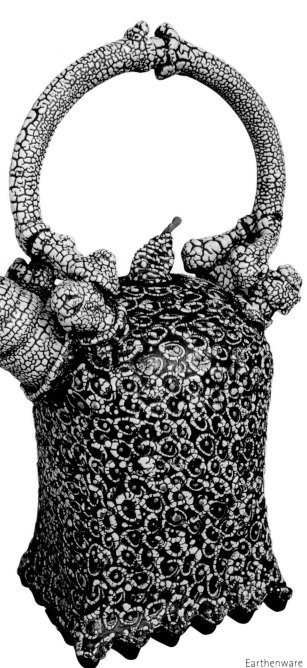

YOSHIRO IKEDA
Teapot

Hand-built earthenware
Glaze and Firing: Manganese glaze,
cone 02-03 oxidation firing

w 14 × h 23 × d 8 inches
w 36 × h 58 × d 20 centimeters

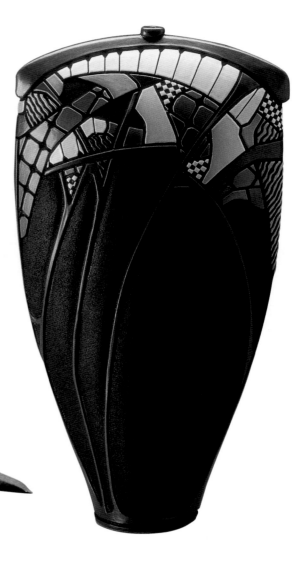

NANCY APRIL
Small-shouldered ovi

Hand-built, slab-built, and
slump-molded earthenware
Glaze and Firing: Airbrushed and hand-painted
glazes, incised textures and pattern, latex mask;
low fire, oxidation multi-firing

w 9 × h 18 × d 4 inches
w 23 × h 46 × d 10 centimeters

PATRICK S. CRABB
Shard T-pot series

Thrown, altered, and extruded earthenware
Glaze and Firing: Cone 06-04 firing in an electric
kiln, raku, sawdust, low-temperature salt firing

w 14 × h 12 × d 6 inches
w 36 × h 30 × d 15 centimeters

KATE WINN
Basket

Thrown and altered earthenware
Glaze and Firing: Majolica glazes, firing
in an electric kiln

w 14 × h 12 inches
w 36 × h 30 centimeters

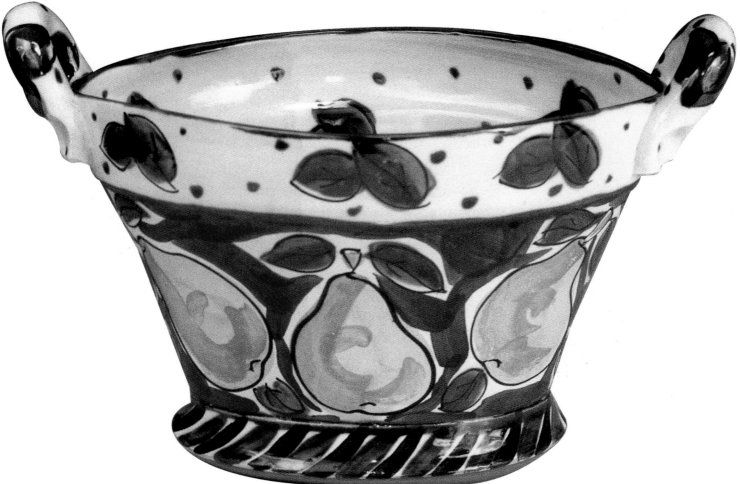

SANDRA LUEHRSEN
Persian heart

Hand-built, coiled, and carved earthenware
Glaze and Firing: Layered slips and glazes, cone
06 oxidation firing in an electric kiln

w 14 × h 21 × d 13 inches
w 36 × h 53 × d 33 centimeters

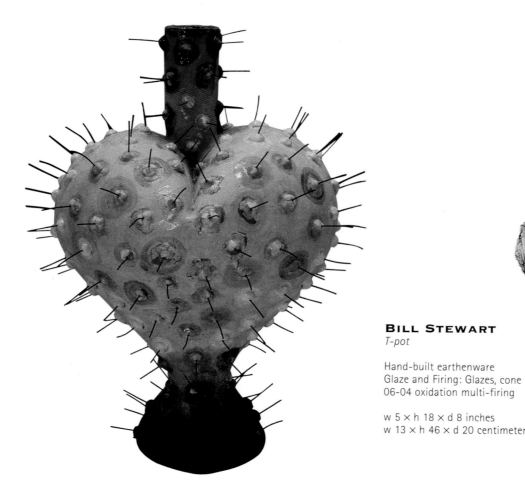

BILL STEWART
T-pot

Hand-built earthenware
Glaze and Firing: Glazes, cone
06-04 oxidation multi-firing

w 5 × h 18 × d 8 inches
w 13 × h 46 × d 20 centimeters

JANE DILLON
Three cookie jars

Thrown, altered, and stacked earthenware
Glaze and Firing: Terra sigillata, slip, and glazes,
cone 04 oxidation firing

w 24 × h 10 × d 10 inches
w 61 × h 25 × d 25 centimeters

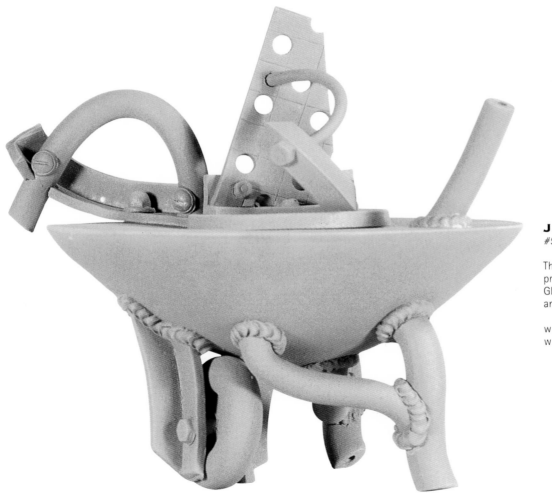

JAKE JACOBSON
#9603

Thrown, hand-built, extruded, and
press-molded earthenware
Glaze and Firing: Lithium, iron sulfate,
and oxidation firing

w 10 × h 7.5 × d 7.5 inches
w 25 × h 19 × d 19 centimeters

GRACE PILATO, IAN STAINTON
Untitled

Thrown and hand-carved raku
Glaze and Firing: Terra sigillata, burnished, raku firing

w 13 × h 6 × d 13 inches
w 33 × h 15 × d 33 centimeters

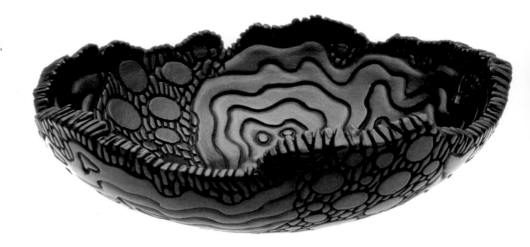

LORI MILLS
Tulip Barge

Thrown and altered earthenware
Glaze and Firing: Glazes, color slips, sgraffito, slip-trailing, cone 05 and 04 oxidation firing in an electric kiln

w 28 × h 18.5 × d 7.5 inches
w 71 × h 47 × d 19 centimeters

FRANK OZEREKO
Verdant

Hand-built earthenware
Glaze and Firing: Sprayed and painted glazes,
cone 04 firing in an electric kiln

w 22 × h 6 × d 3 inches
w 56 × h 15 × d 8 centimeters

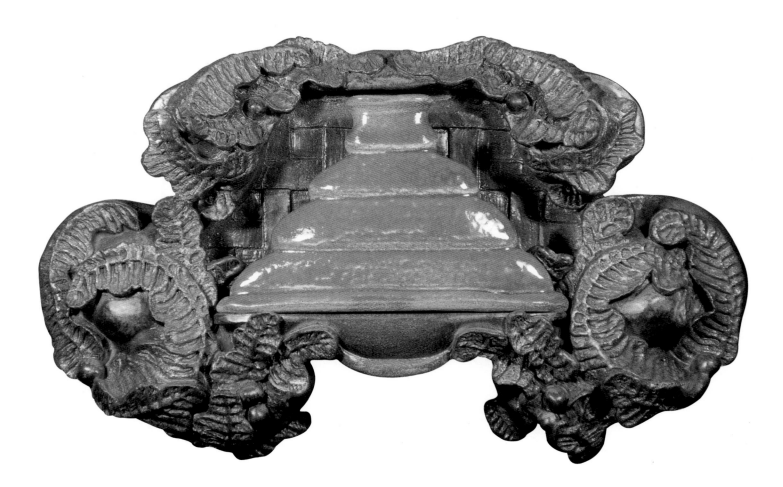

CLAUDIA REESE
Carnival

Press-molded earthenware
Glaze and Firing: Clear glaze, sgraffito, cone 04

w 20 × h 20 × d 2.5 inches
w 51 × h 51 × d 6 centimeters

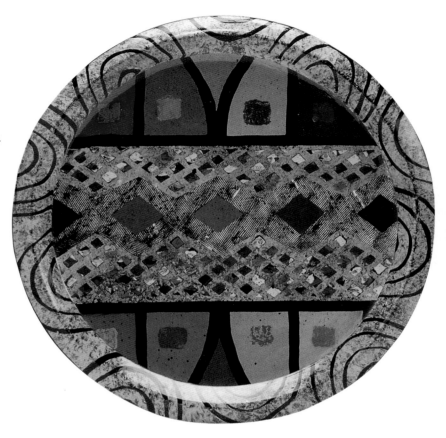

LINDA GANSTROM
Great Mother mugs

Slab-built earthenware
Glaze and Firing: Terra sigillata, cone 04
oxidation firing in an electric kiln

w 20 × h 6 × d 3 inches
w 51 × h 15 × d 8 centimeters

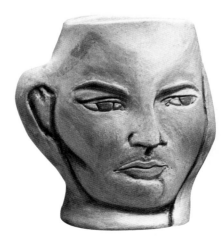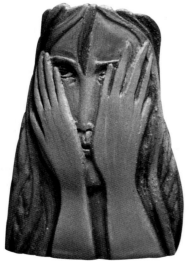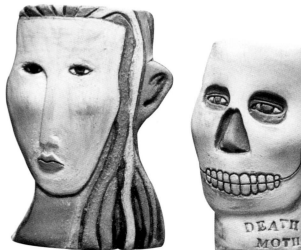

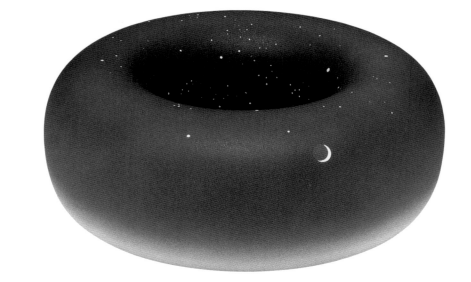

DON JONES
Cone with Dull Moon and Clouds

Thrown closed-cone earthenware
Glaze and Firing: Clear glaze, underglazes,
firing to cone 05

w 8 × h 18.5 × d 8 inches
w 20 × h 47 × d 20 centimeters

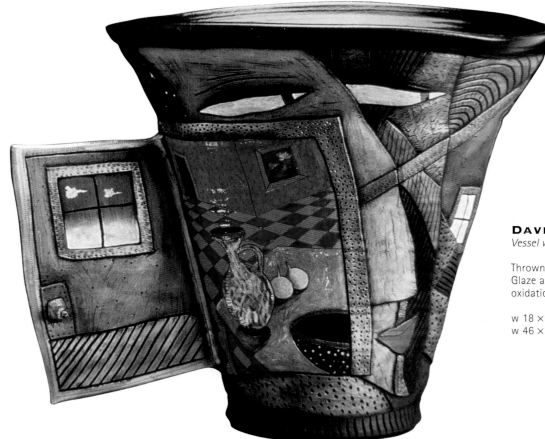

DAVID STABLEY
Vessel with open door

Thrown and slab-built earthenware
Glaze and Firing: Glazed interior, underglaze,
oxidation firing

w 18 × h 20 × d 12 inches
w 46 × h 51 × d 30 centimeters

LUCY BRESLIN
Summer Song #6

Thrown, altered, and hand-built earthenware
Glaze and Firing: Cone 04 firing in an
electric kiln

w 10 × h 9 × d 10 inches
w 25 × h 23 × d 25 centimeters

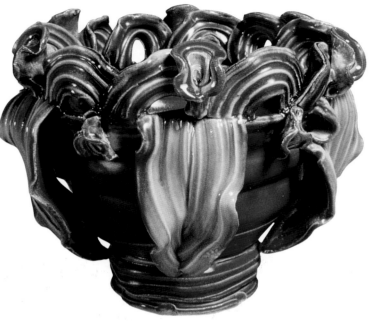

PETER SHIRE
Mayan Tableaux

Hand-built, slab-built, molded, and extruded
earthenware
Glaze and Firing: Clear underglaze, cone 06
firing

w 36 × h 21 × d 11 inches
w 93 × h 53 × d 28 centimeters

photo: William Nettles

SHELLIE Z. BROOKS
Crater Lake: Floating Basket
(collection of Edythe Zimmerman)

Press-molded and defloculated slip slabs poured
on plaster-slab earthenware
Glaze and Firing: Airbrushed underglaze, low-fire
firing in an electric kiln

w 12 × h 10 × d 12 inches
w 30 × h 25 × d 30 centimeters

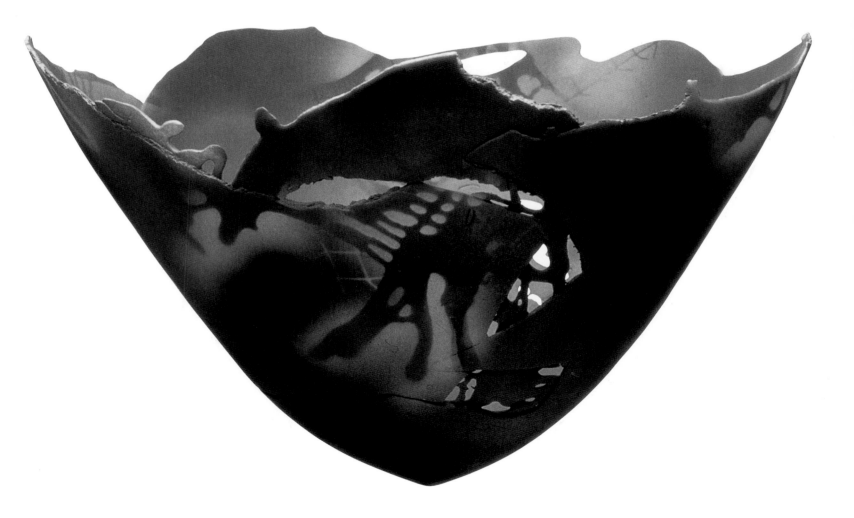

BRADLEY KEYS
Buffalo Jump Pot

Thrown and assembled earthenware with
hand-built additions
Glaze and Firing: Terra sigillata, cone 04
firing in an electric kiln

h 20 × d 10 inches
h 51 × d 25 centimeters

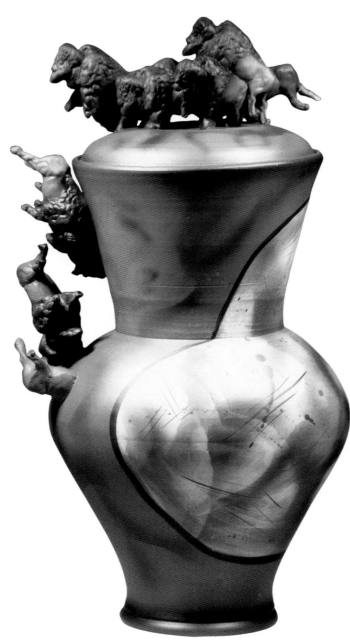

POSEY BACOPOULOS
Beaked pitcher

Thrown, altered, and assembled
earthenware
Glaze and Firing: Majolica glaze, stains,
cone 04 firing in an electric kiln

w 7.5 × h 7 × d 3 inches
w 19 × h 18 × d 8 centimeters

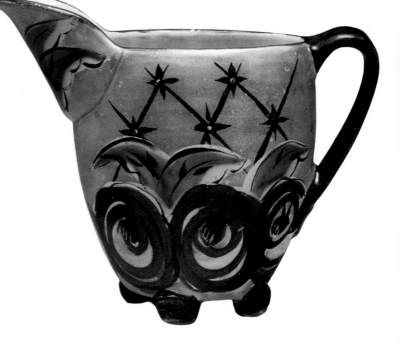

Thrown and hand-built earthenware
Glaze and Firing: Glazes, China paints, decals,
luster, firing in an electric kiln

w 13.25 × h 11.25 × d 7 inches
w 34 × h 29 × d 18 centimeters

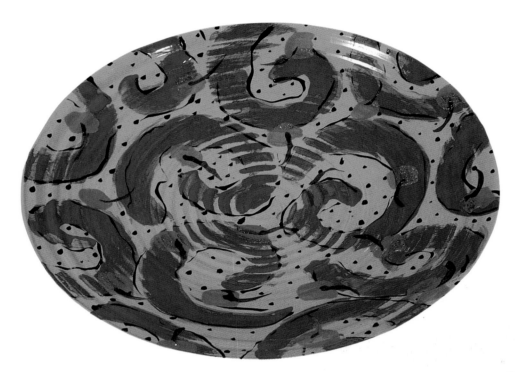

LESLIE ECKMANN
Red Hot

Thrown earthenware
Glaze and Firing: Clear glaze, oxidation firing

d 19 inches
d 48 centimeters

KEVIN A. MYERS
Untitled 11/1997

Thrown, altered, cut, incised, and
slip-trailed earthenware
Glaze and Firing: Chrome red glaze, cone 06
firing, cone 018 firing

w 6 × h 8 × d 8 inches
w 15 × h 20 × d 20 centimeters

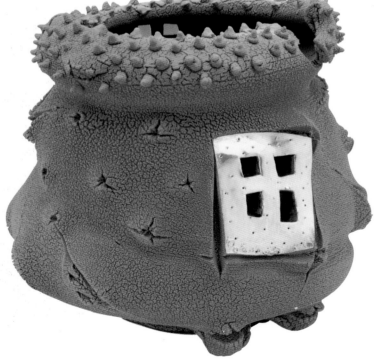

DONNA GREEN
Vessel 1997

Coil-built earthenware
Glaze and Firing: Slips and oxidation under a
clear glaze, oxidation firing

w 18 × h 29.5 inches
w 46 × h 75 centimeters

KATHY ERTEMAN
Tall vessel

Slip-cast earthenware (from thrown original)
Glaze and Firing: Brushed clear glaze over black
carved underglaze, oxidation firing

w 8 × h 12 × d 8 inches
w 20 × h 30 × d 20 centimeters

photo: D. James Dee

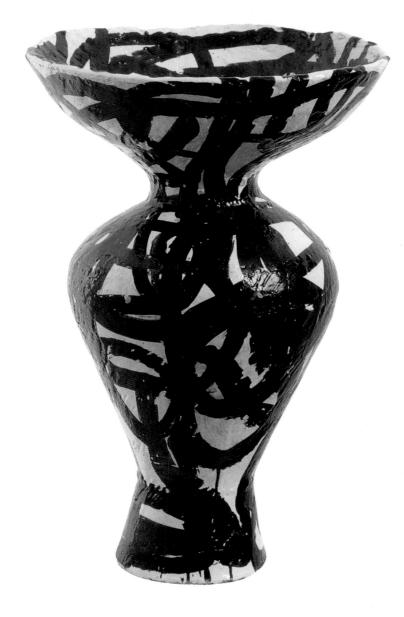

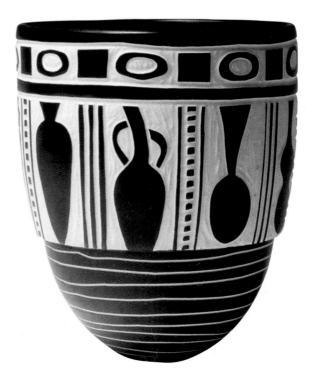

DAVID CALVIN HEAPS
Left-handed winged cup with lap plate

Slip-cast earthenware
Glaze and Firing: Matte glaze, gloss green glaze,
oxidation firing

w 5.5 × h 4.5 × d 4 inches (cup)
w 14 × h 11 × d 10 centimeters (cup)
w 14 × h 2 × d 11.5 inches (plate)
w 36 × h 5 × d 39 centimeters (plate)

JARED JAFFE
Funky Teapot

Slip-cast and hand-built earthenware
Glaze and Firing: Low-fire firing in an
electric kiln

w 4 × h 9 × d 4 inches
w 10 × h 23 × d 10 centimeters

SYBILLE ZELDIN
Floral bowl

Hand-built earthenware
Glaze and Firing: Majolica glaze, low-fire
firing in an electric kiln

h 9 × d 16 inches
h 23 × d 41 centimeters

MARY CARROLL
Comparettia Speciosa

Hand-built earthenware with press-molded relief
Glaze and Firing: Polychrome glazes, cone 02
oxidation firing

w 16 × h 20 × d 16 inches
w 41 × h 51 × d 41 centimeters

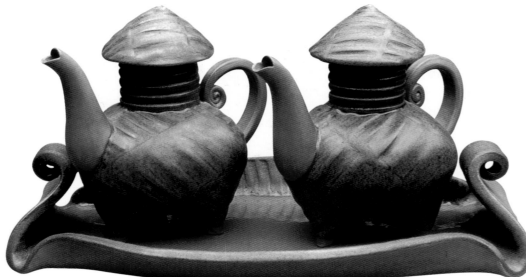

SANDI PIERANTOZZI
Chimney-cap cruet set

Slab-built earthenware
Glaze and Firing: Low fire glaze, cone
04 bisque/cone 05 glaze, firing in an
electric kiln

w 10 × h 6 × d 5 inches
w 25 × h 15 × d 13 centimeters

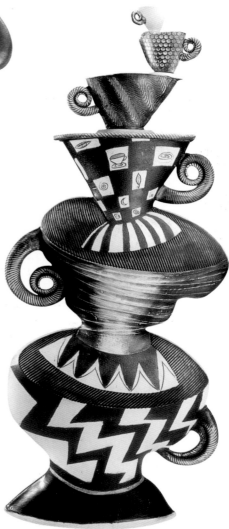

ANNE SCHIESEL-HARRIS
Tumbling Teacups

Hand-built and slab-built
Glaze and Firing: Stains, glazes, cone 06
oxidation firing

w 13 × h 29 × d 4 inches
w 33 × h 74 × d 10 centimeters

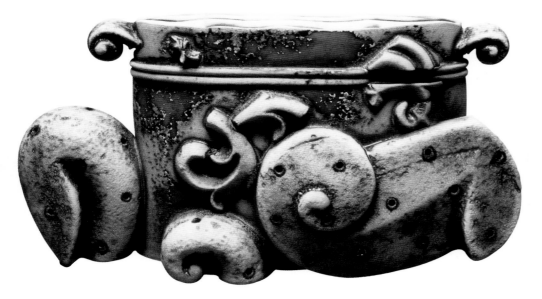

MARK DERBY
French curve

Slab-built, press-molded, and
extruded earthenware
Glaze and Firing: Sprayed slip and glaze, soda
glaze over crackle slip during
oxidation firing

w 17 × h 8 × d 6 inches
w 43 × h 20 × d 15 centimeters

JOHN GOODHEART
Fra Bernardo's Sin Maker

Slab-built earthenware
Glaze and Firing: Dipped lithium glaze, cone 06
oxidation firing in an electric kiln

w 9 × h 7 × d 3 inches
w 23 × h 18 × d 8 centimeters

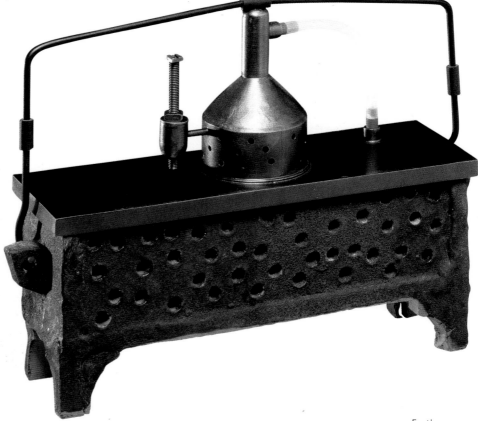

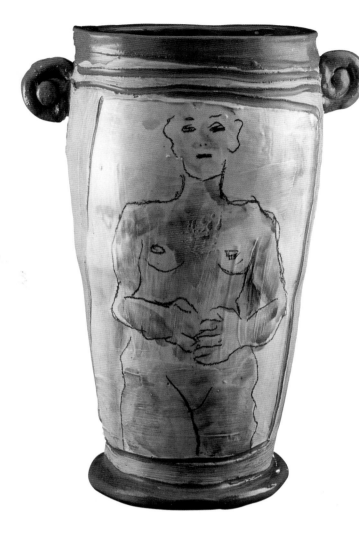

DONNA MCGEE
Elizabeth Man

Thrown and altered earthenware with
coil handles
Glaze and Firing: Sgraffito, slips,
underglazes, cone 03 oxidation firing

w 9 × h 14 × d 7 inches
w 23 × h 36 × d 18 centimeters

JAMES C. WATKINS
Raku teapot

Thrown and hand-built earthenware
Glaze and Firing: Unglazed, terra sigillata, raku
glaze, sagger firing

w 14 × h 15 inches
w 36 × h 38 centimeters

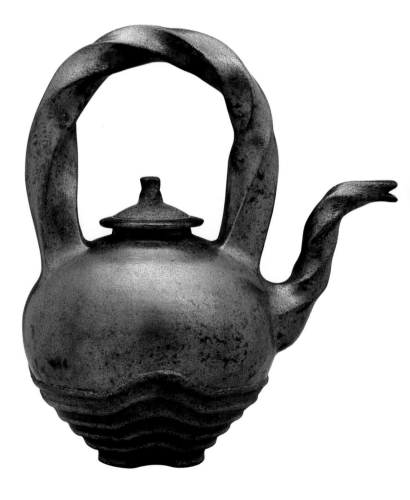

PIERO FENCI
Sakai Shaker Hatbox

Hand-built earthenware
Glaze and Firing: Cone 06-04 raku firing

w 15 × h 9 × d 15 inches
w 38 × h 23 × d 38 centimeters

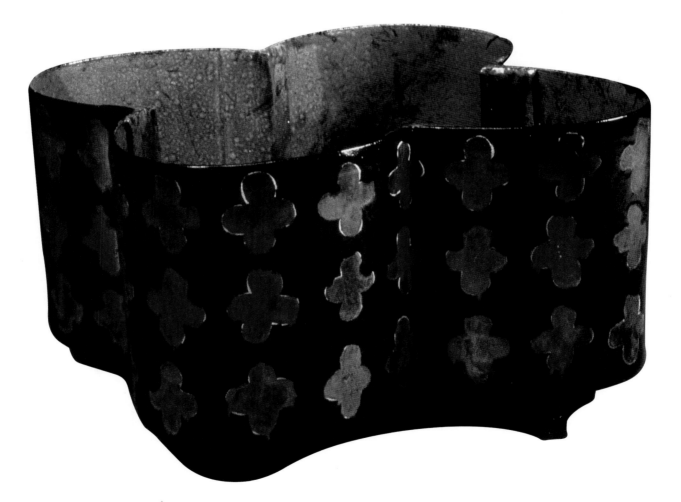

JENNIE BIRELINE
Amazon Origami #3

Hand-built and slab-built earthenware
Glaze and Firing: Terra sigillata, firing to cone 04

h 21.75 inches
h 56 centimeters

ELAINE ALT
Waves

Thrown and hand-built earthenware
Glaze and Firing: Underglazes and luster,
multi-firing in an electric kiln

w 6.5 × h 15 inches
w 17 × h 38 centimeters

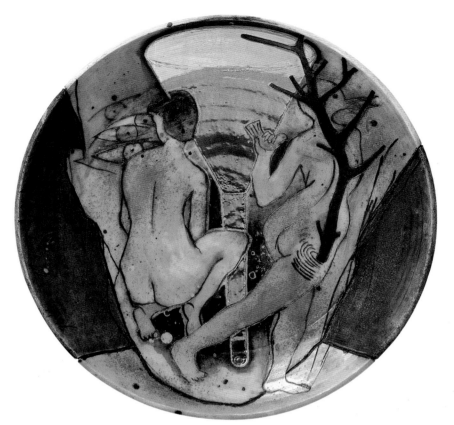

STAN WELSH, MARGITTA DIETRICK
Golden Funnel—1997

Thrown earthenware
Glaze and Firing: Cone 04 underglazes, cone 04
glazes, cone 018 gold luster, oxidation firing

w 24 × h 24 × d 4 inches
w 61 × h 61 × d 10 centimeters

CLARK BURGAN
Dinner set

Thrown earthenware
Glaze and Firing: Cone 04 firing in an
electric kiln

w 14 × h 3 inches (largest plate)
w 36 × h 8 centimeters (largest plate)

WOODY HUGHES
Steam-iron teapot

Thrown, altered, and assembled
earthenware
Glaze and Firing: Terra sigillata, transparent
glazes, firing in an electric kiln

w 14 × h 9 × d 4 inches
w 36 × h 23 × d 10 centimeters

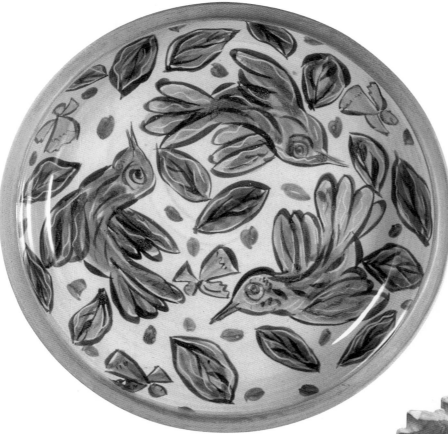

DIANE KENNEY
Bird Platter

Thrown earthenware
Glaze and Firing: Majolica glaze,
cone 05 firing in an electric kiln

w 20 × h 3 × d 2.5 inches
w 51 × h 8 × d 6 centimeters

RICHARD HIRSCH
Primal Cup #2

Thrown and hand-built earthenware
Glaze and Firing: Low-fire firing in an
electric kiln, raku

w 10 × h 8.75 × d 5 inches
w 25 × h 22.5 × d 13 centimeters

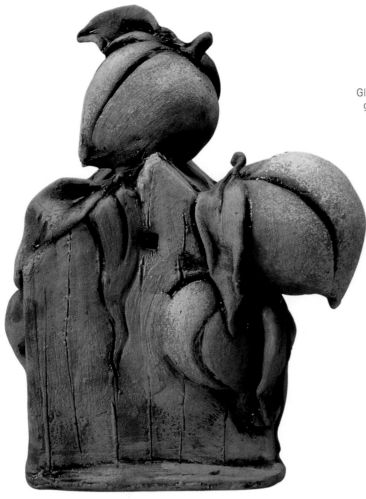

SUSAN BOSTWICK
The Harvest of Burden and Delight

Hand-built earthenware
Glaze and Firing: Layered underglazes and
glazes, oxidation firing in an electric kiln

w 5 × h 7 × d 4 inches
w 13 × h 18 × d 10 centimeters

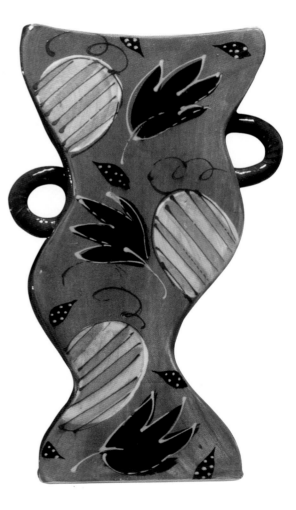

JUDY KOGOD COLWELL
Melon vase

Hand-built earthenware
Glaze and Firing: Clear glaze, underglaze slips,
stains, slip trailing, resists, cone 05 firing in an
electric kiln

w 6 × h 16 × d 2 inches
w 15 × h 41 × d 5 centimeters

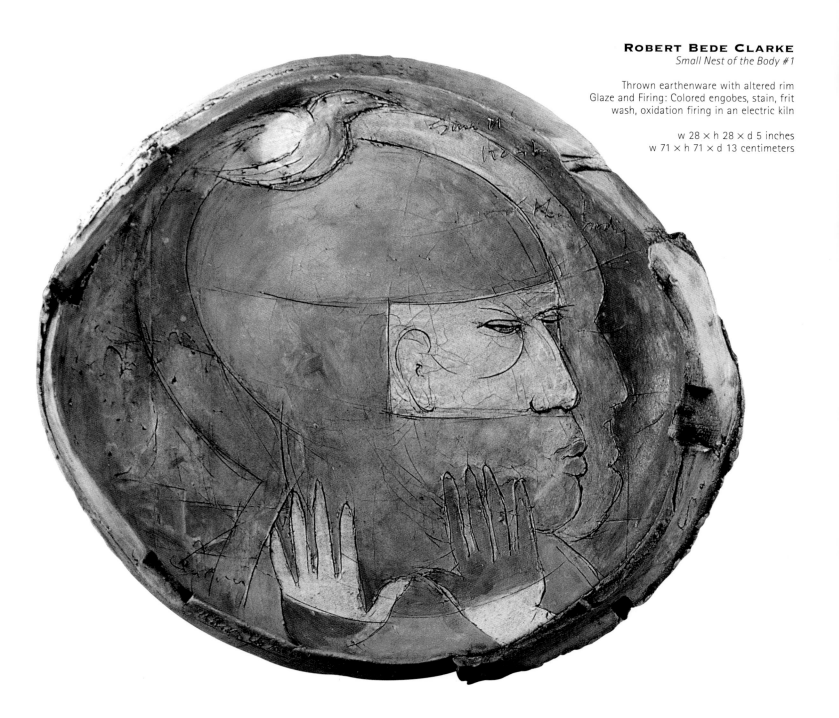

ROBERT BEDE CLARKE
Small Nest of the Body #1

Thrown earthenware with altered rim
Glaze and Firing: Colored engobes, stain, frit
wash, oxidation firing in an electric kiln

w 28 × h 28 × d 5 inches
w 71 × h 71 × d 13 centimeters

GREG PAYCE
Wake

Thrown earthenware using templates
Glaze and Firing: Terra sigillata exterior, glazed
interior, cone 04 oxidation firing

w 21.5 × h 8.5 × d 7 inches
w 55 × h 21 × d 18 centimeters

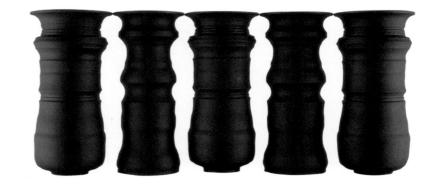

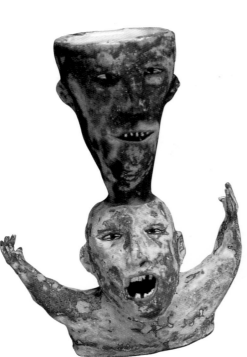

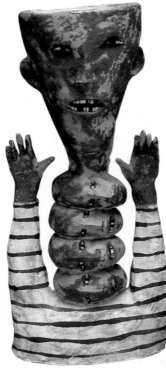

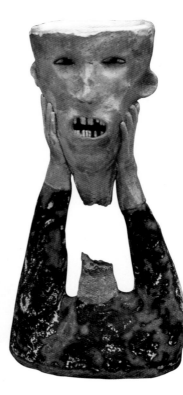

WESLEY ANDEREGG
Goblets

Pinched earthenware
Glaze and Firing: Low-fire glazes
and slips, firing in an electric kiln

w 3 × h 7 × d 2 inches
w 8 × h 18 × d 5 centimeters

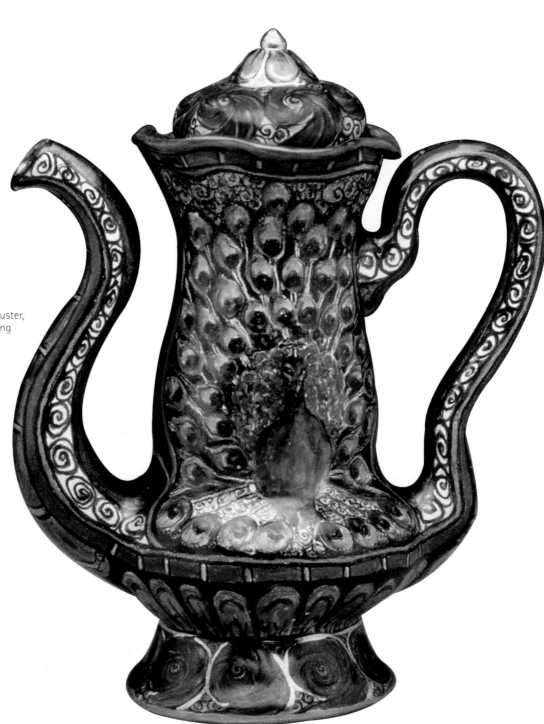

ROSALIE WYNKOOP
Rubaiyat teapot

Thrown and hand-built earthenware
Glaze and Firing: Majolica glaze, gold luster,
China paint; cone 05 and cone 018 firing
in an electric kiln

w 4.5 × h 12 × d 9 inches
w 11 × h 30 × d 23 centimeters

CLAUDETTE GERHOLD, PAUL GERHOLD

Thrown raku body

Glaze and Firing: Brushed silver and tin, raku firing in electric kiln

w 8 × h 18 × d 8 inches
w 20 × h 46 × d 20 centimeters

LEOPOLD L. FOULEM

Blue-and-white teapot with Oriental Landscapes

Hand-built earthenware
Glaze and Firing: Decals,
firing in an electric kiln

w 11.75 × h 11.75 × d 5.5 inches
w 30 × h 30 × d 14 centimeters

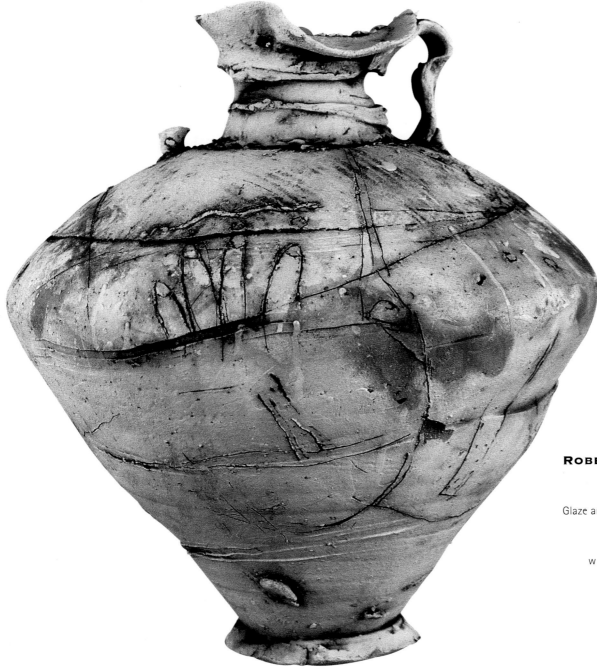

ROBERT BEDE CLARKE
Minoan (#3)

Thrown earthenware
Glaze and Firing: Engobes and stains,
sagger firing

w 16 × h 20 × d 16 inches
w 41 × h 51 × d 41 centimeters

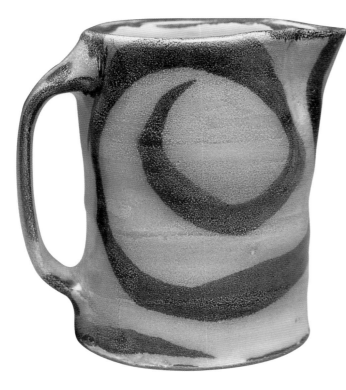

STEVE DAVIS-ROSENBAUM
Creamer

Thrown earthenware
Glaze and Firing: Majolica glaze, colored
stains, firing in an electric kiln

w 3.5 × h 5 inches
w 9 × h 13 centimeters

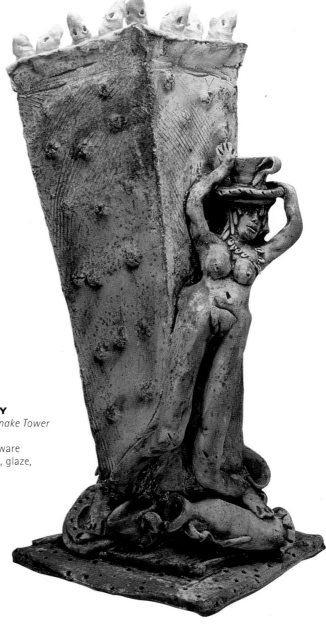

GEORGE MCCAULEY
Light Headed Goddess of The Snake Tower

Thrown and slab-built earthenware
Glaze and Firing: Terra sigillata, glaze,
soda firing to cone 01

w 9.25 × h 22.5 inches
w 24 × h 57 centimeters

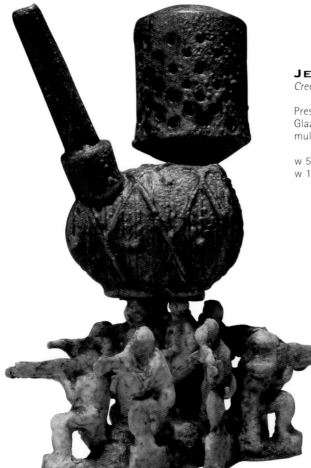

JEROD MORRIS
Creamer

Press-molded and slab-built earthenware
Glaze and Firing: Low-fire lithium glazes,
multi-firing in electric kiln

w 5 × h 7 × d 3 inches
w 13 × h 18 × d 8 centimeters

EMMETT LEADER
Animal in Wagon #2

Thrown and hand-built earthenware
Glaze and Firing: Terra sigillata,
firing in an electric kiln

w 8 × h 15 × d 6 inches
w 20 × h 38 × d 15 centimeters

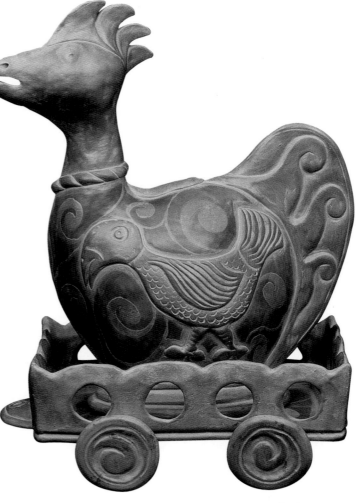

PORCELAIN

The term "porcelain" describes both clay composition and firing temperature. Generally speaking, porcelain is a glassified, vitreous clay body fired in temperature ranges from cone 6 to cone 14. However, many potters fire their work multiple times, using different temperatures for clay, glazes, luster, and other embellishment. The pottery that appears in this section was designated porcelain by the contributing artists: the section title is intended only in its broadest sense.

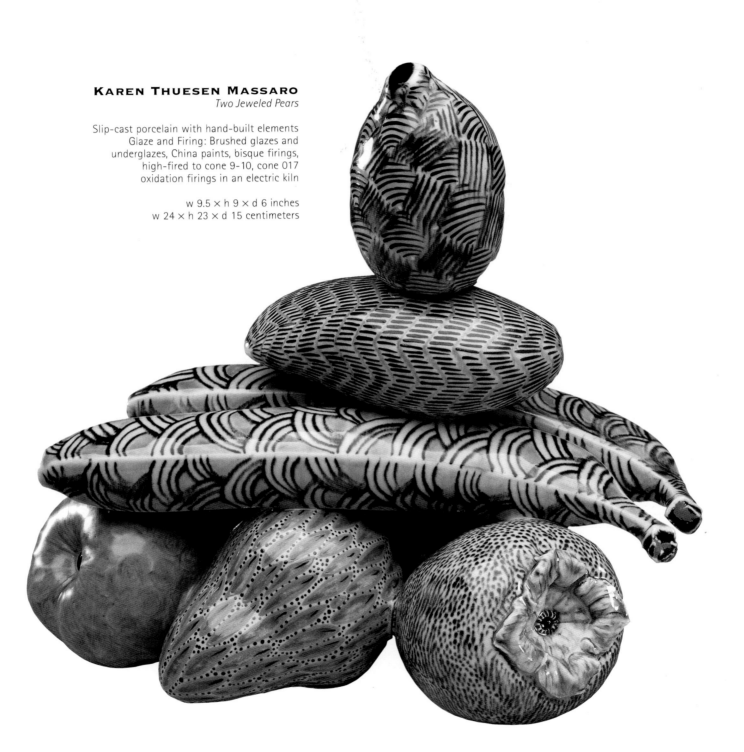

KAREN THUESEN MASSARO
Two Jeweled Pears

Slip-cast porcelain with hand-built elements
Glaze and Firing: Brushed glazes and
underglazes, China paints, bisque firings,
high-fired to cone 9-10, cone 017
oxidation firings in an electric kiln

w 9.5 × h 9 × d 6 inches
w 24 × h 23 × d 15 centimeters

SUNYONG CHUNG
Small bowls

Hump-molded porcelain
Glaze and Firing: Clear glaze, high-temperature
firing in an electric kiln

h 4.5 × d 6 inches
h 11 × d 15 centimeters

ELSA RADY
Still Life #70

Thrown and carved porcelain
Glaze and Firing: Spray, cone 8 firing

w 18 × h 18 × d 11 inches
w 46 × h 46 × d 28 centimeters

BARBARA SEBASTIAN
Spiral

Thrown porcelain
Glaze and Firing: Copper red glaze,
cone 10 firing

w 5 × h 2 × d 4 inches
w 13 × h 5 × d 10 centimeters

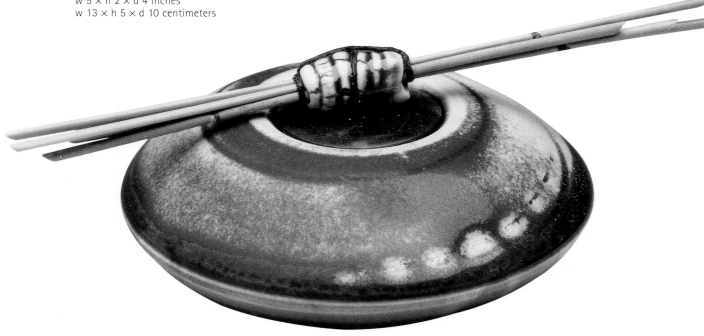

ELIZABETH ROMAN
Sapplio

Thrown and altered porcelain
Glaze and Firing: Airbrushed cushing semi-matte
glaze, cone 10 oxidation firing

w 6 × h 12.5 × d 6 inches
w 15 × h 32 × d 15 centimeters

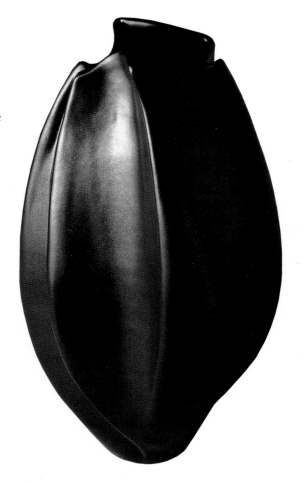

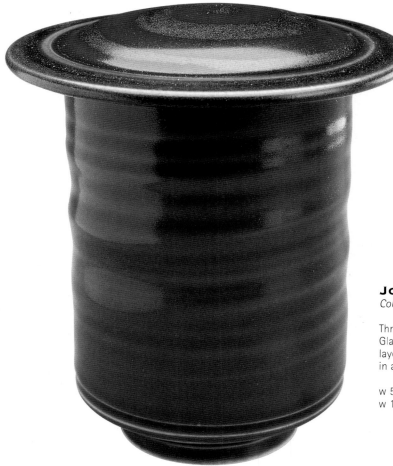

JOANNE KIRKLAND
Cobalt jar

Thrown and altered porcelain
Glaze and Firing: Wax resist, multi-colored
layering, sgraffito, cone 10 and cone 11 firing
in a natural gas downdraft kiln

w 5 × h 3.75 inches
w 13 × h 10 centimeters

LES LAWRENCE
New Vision—Teapot #A60901

Hand-built porcelain
Glaze and Firing: Single firing

w 3 × h 9 × d 15 inches
w 8 × h 23 × d 38 centimeters

LAURA WILENSKY
Neighborly Advice

Hand-built porcelain
Glaze and Firing: Cone 10 clear with
underglaze stains, cone 018 china paints,
firing in an electric kiln

w 9 × h 6 × d 6 inches
w 23 × h 15 × d 15 centimeters

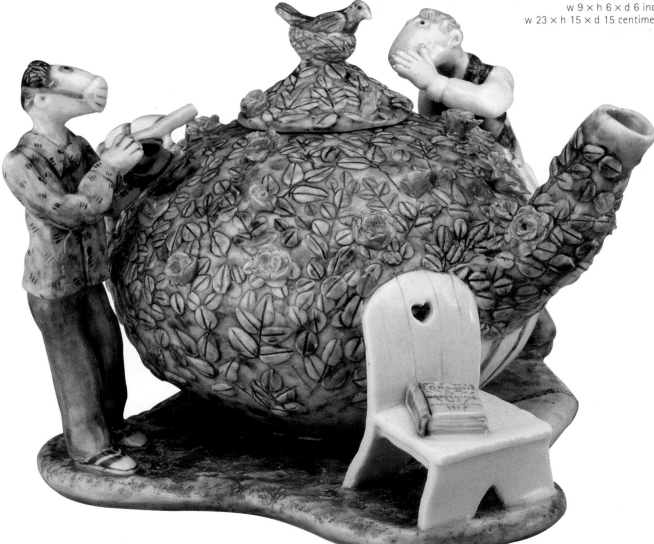

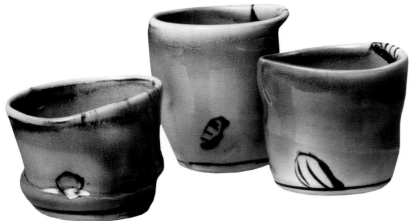

VICTORIA D. CHRISTEN
Three blue cups

Thrown and altered porcelain
Glaze and Firing: Copper glaze, cone 10 soda
firing, cone 10 oxidation firing

w 3 × h 3 × d 3 inches
w 8 × h 8 × d 8 centimeters

STEPHEN FABRICO
Spiral bowl

Thrown and hand-carved porcelain
Glaze and Firing: Sprayed, dipped, cone 10 firing

w 16 × h 5 × d 16 inches
w 41 × h 13 × d 41 centimeters

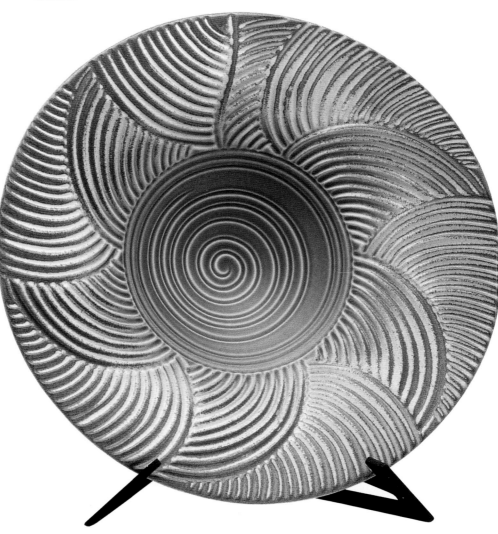

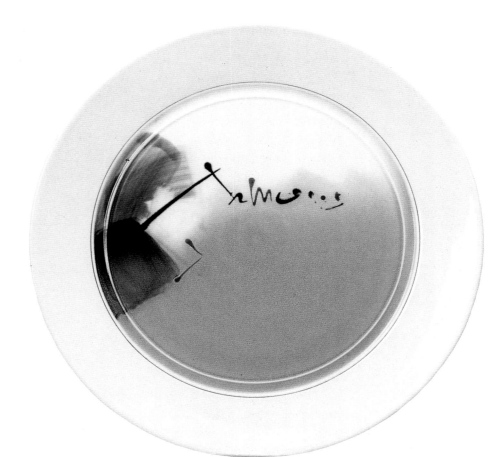

JOSEPH A. TRIPLO
Platter

Thrown, hand-built, molded, and cast porcelain
Glaze and Firing: Brushed, sprayed, dipped,
high-fire cone 11 firing in a gas kiln

d 15 inches
d 38 centimeters

MINAKO YAMANE-LEE
Sunset

Thrown porcelain with altered rim
Glaze and Firing: Sprayed matte
crystalline glazes, light reduction
cone 10 firing in a gas kiln

w 5 × h 4.5 × d 5 inches
w 13 × h 11 × d 13 centimeters

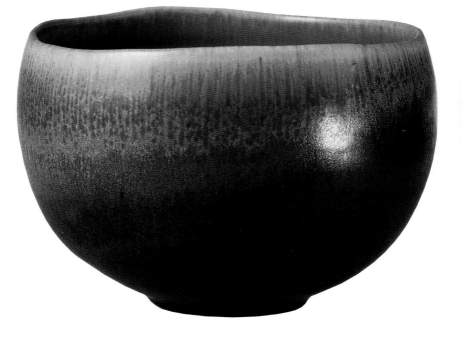

KATHRYN INSKEEP
Slab-built porcelain

Glaze and Firing: Soda ash, wood ash,
 volcanic ash, reduction firing

w 10 × h 13 inches
w 25 × h 33 centimeters

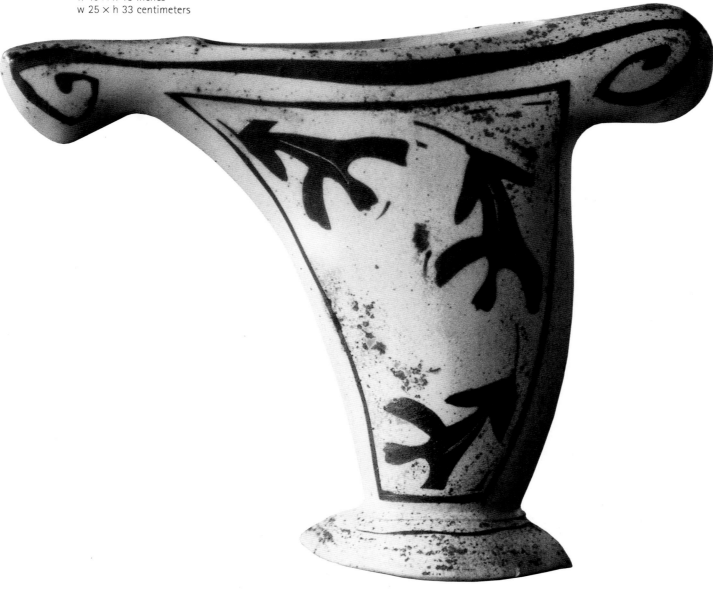

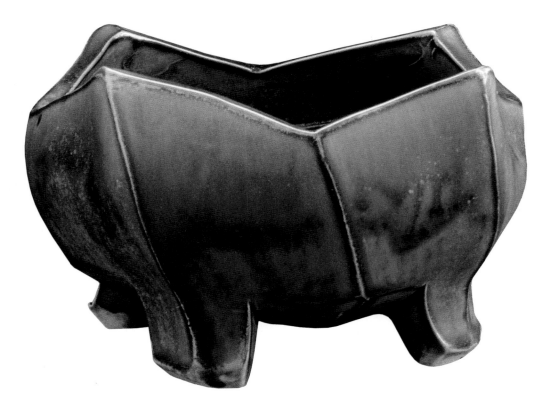

MEGAN HART
Teapot, cup, and saucer

Thrown and slab-built porcelain
Glaze and Firing: Painted with colored slips,
clear glaze, cone 11 gas reduction firing

w 3.5 × d 2.73 inches (cup)
w 9 × d 7 centimeters (cup)
h 7.5 inches (pot)
h 19 centimeters (pot)

GERTRUDE GRAHAM SMITH
Bowl

Thrown and altered porcelain
Glaze and Firing: Single firing to cone 10
in soda kiln

w 8 × h 6 inches
w 20 × h 15 centimeters

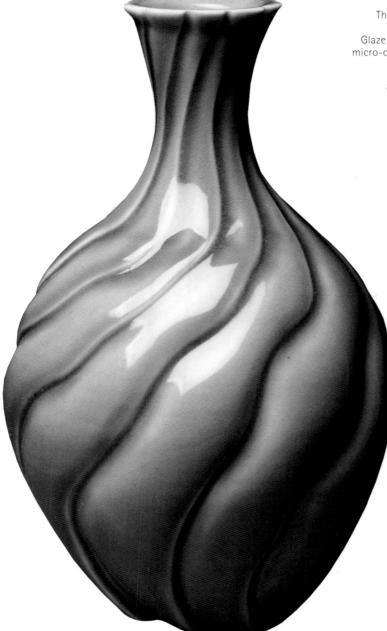

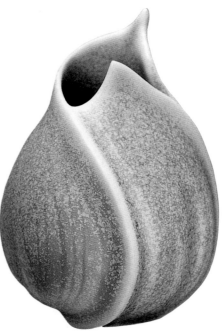

SANDRA BYERS
Springing #2

Thrown, pinched, cut, incised, and
extruded porcelain
Glaze and Firing: Dipped and sprayed
micro-crystalline matte glazes, cone 10
oxidation firing

w 2.25 × h 3.13 × d 2.13 inches
w 6 × h 8 × d 5 centimeters

IAN STAINTON
Altered Vase #2

Thrown and altered porcelain
Glaze and Firing: Celadon glaze, cone
10 oxidation firing

w 7 × h 12.5 inches
w 18 × h 32 centimeters

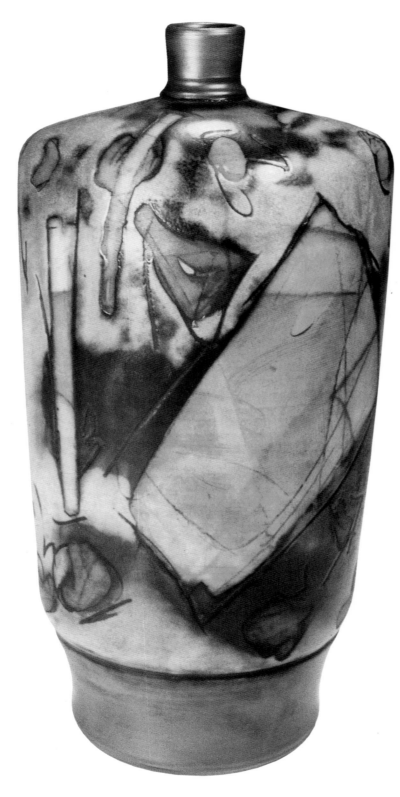

REGIS C. BRODIE
Oval bottle

Thrown and distorted porcelain
Glaze and Firing: Barry's blue glaze, wax resist,
cone 9 and 10 reduction firing

h 14 inches
h 36 centimeters

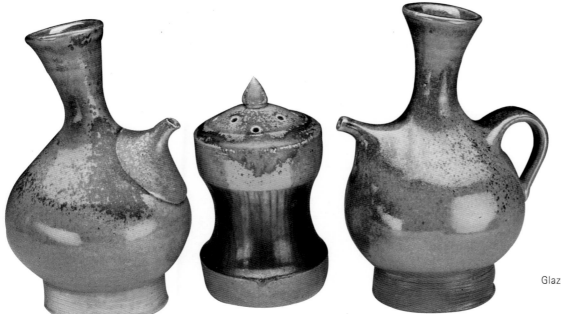

THOMAS ROHR
Salad set

Thrown porcelain
Glaze and Firing: Shino glaze,
wood firing in a kiln

w 12 × h 8 × d 4 inches
w 30 × h 20 × d 10 centimeters

DIANE KENNEY
Teapot set

Thrown porcelain
Glaze and Firing: Glazed interior,
cone 10 and cone 11 wood firing

w 8 × h 7 × d 6 inches
w 20 × h 18 × d 15 centimeters

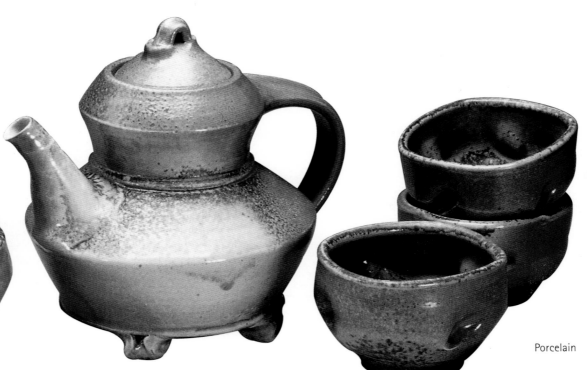

KAREN THUESEN MASSARO
Two Nested Bowls

Thrown porcelain
Glaze and Firing: Poured interior glazes, dipped
exterior glazes, underglazes, wax resist, overglaze,
inlayed glazes, China paints, luster, bisque firing,
high-firing to cone 9-10, cone 17 oxidation
firing in an electric kiln

w 6.5 × h 4 × d 10.5 inches
w 17 × h 10 × d 27 centimeters

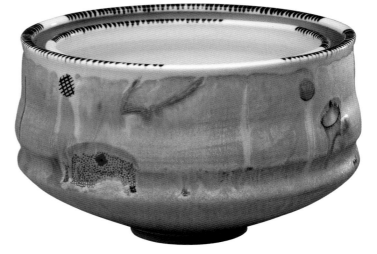

DONNA ANDEREGG
Sugar Jars

Thrown porcelain
Glaze and Firing: Slips, salt firing

w 5 × h 6 × d 5 inches
w 13 × h 15 × d 13 centimeters

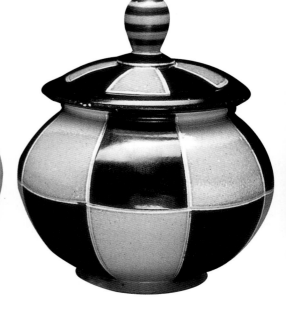

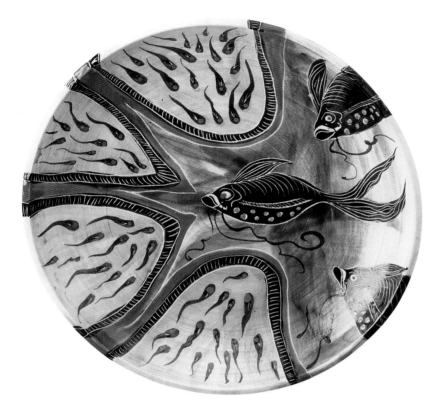

DEANNA ECKELS
Heading Home

Thrown porcelain
Glazing and Firing: Stains, clear glaze,
underglazes, sgraffito, cone 10 reduction firing

w 18 × h 2 inches
w 46 × h 5 centimeters

EVE FLECK
Covered Bowl

Thrown porcelain with
attatched handle
Glaze and Firing: Clear glaze,
underglaze, sgraffito cone 07
oxidation firing

w 6.5 × h 8 inches
w 17 × h 20 centimeters

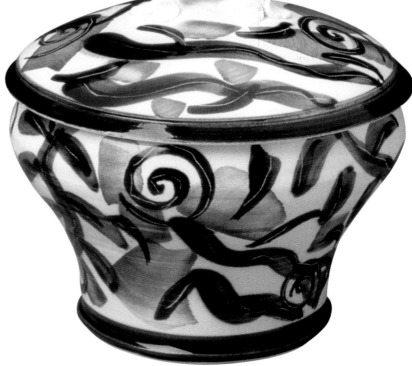

BERRY MATTHEWS
Grace Under Fire

Slab-built porcelain
Glaze and Firing: Cone 10 oxidation firing

w 12 × h 7 × d 6 inches
w 30 × h 18 × d 15 centimeters

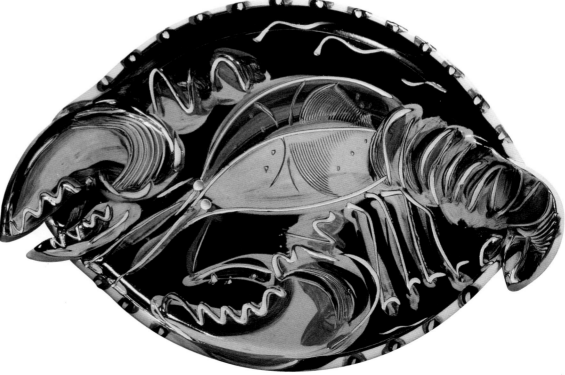

KATHRYN SHARBAUGH
Grosgrain

Hand-built porcelain
Glaze and Firing: Underglaze, clear glaze,
cone 10 oxidation firing

w 12 × h .75 × d 12 inches
w 30 × h 2 × d 30 centimeters

MARIAN BAKER
Lobster platter

Thrown and altered porcelain
Glaze and Firing: Colored slips, clear glaze,
cone 6 oxidation firing in an electric kiln

w 15 × h 2 × d 10 inches
w 38 × h 5 × d 25 centimeters

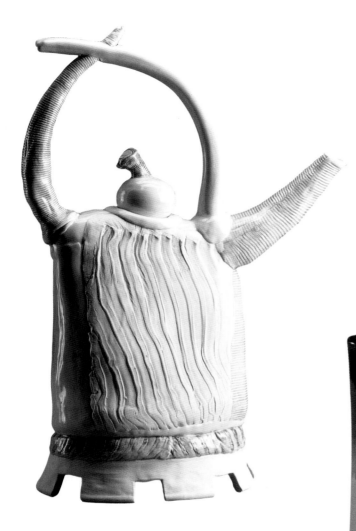

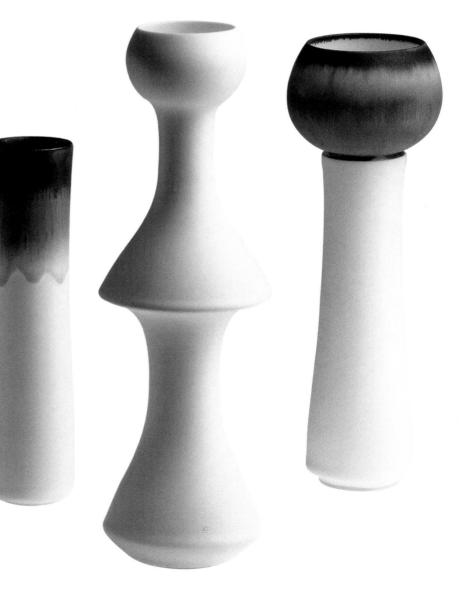

CAROLYN CHESTER
Three vases

Thrown and turned porcelain
Glaze and Firing: Slip with metal oxides under
Wollastonite glaze, cone 9 oxidation firing

w 4 × h 13 inches
w 10 × h 33 centimeters

GINA FREUEN
Cut foot-strap handled with water vessel

Thrown and hand-built porcelain
Glaze and Firing: Clear glaze over stains
and engobes, cone 5 slight-reduction firing
in a gas downdraft kiln

w 18 × h 22 × d 8 inches
w 46 × h 56 × d 20 centimeters

MARIE J. PALLUOTTO
Patchwork cup and saucer

Thrown porcelain with stamped impressions
Glaze and Firing: Incising, colored slips,
cone 10 oxidation glaze, firing in an
electric kiln

w 3 × h 4.4 × d 4 inches
w 8 × h 11 × d 10 centimeters

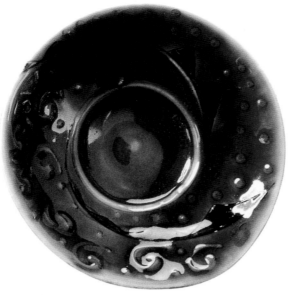

SUSAN MEREDITH BUNZL
Cup series

Thrown porcelain
Glaze and Firing: Barium matte glaze, black
engobe, firing at 1260°C in an electric kiln

w 6.75 × h 3.5 × d 3.25 inches
w 17 × h 9 × d 8.5 centimeters

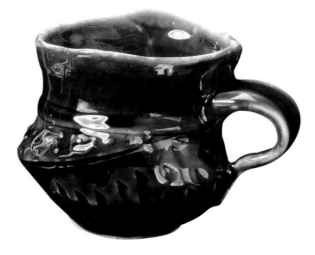

HARRIS DELLER

Square-shaped dish with concentric arcs

Hand-built porcelain
Glaze and Firing: Incised surface, inlayed glaze,
cone 10 reduction firing

w 12 × h 3 × d 12 inches
w 30 × h 8 × d 30 centimeters

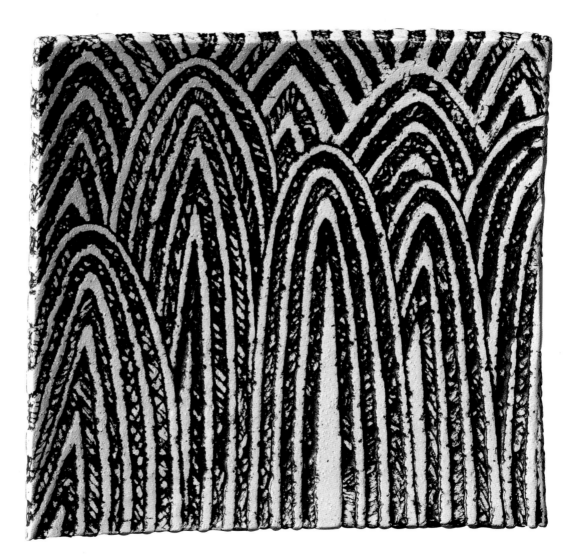

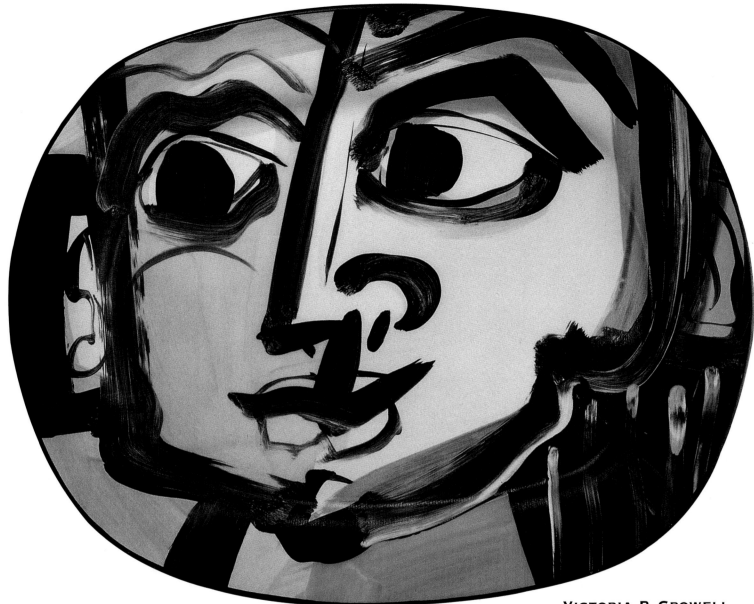

VICTORIA P. CROWELL
Looking East

Press-molded porcelain
Glaze and Firing: Hand-painted with colored
slips, cone 10 oxidation firing

w 14 × h 1 × d 17 inches
w 36 × h 3 × d 43 centimeters

ANDREA FÁBREGA
Ewer with Twisted Handle

Thrown porcelain
Glaze and Firing: Rutile blue with copper
red spots, high-fire reduction firing in kiln

w 1 × h 1.25 × d 1 inches
w 3 × h 4 × d 3 centimeters

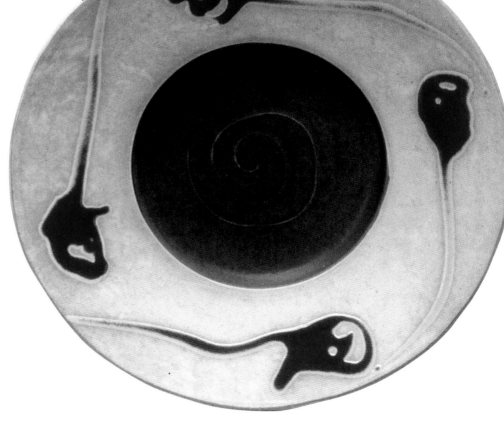

DON DAVIS
Flared plate

Thrown porcelain
Glaze and Firing: Sprayed oxide, sponging,
glaze, slip trails, cone 7 light reduction firing

w 12 × h 2 × d 12 inches
w 30 × h 5 × d 30 centimeters

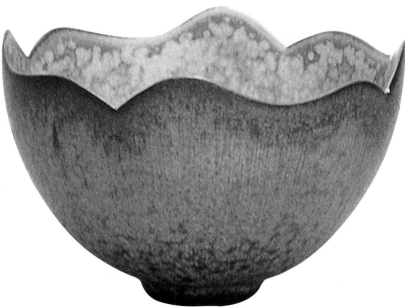

IRA BATES
Bowl

Thrown porcelain
Glaze and Firing: Rutile matte, cone
10 oxidation firing

w 6 × h 4 inches
w 15 × h 10 centimeters

**RONALEE HERRMANN
AND ALFRED STOLKEN**
Untitled

Thrown, altered, and carved porcelain
Glaze and Firing: Crystalline glaze, firing in
a modified electric kiln, gas reduction firing

h 13 x d 7 inches
h 33 x d 18 centimeters

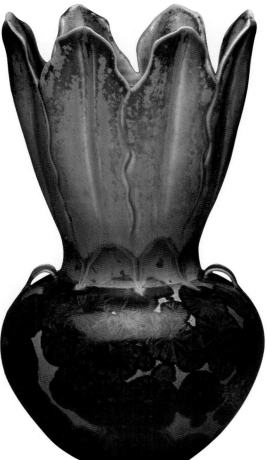

LEAH LEITSON
Lobed sauce boat

Thrown and altered porcelain
Glaze and Firing: Salt firing

w 3.5 × h 4 × d 5 inches
w 9 × h 10 × d 13 centimeters

ALAN AND BRENDA NEWMAN
Tulip bowl

Molded and altered porcelain
Glaze and Firing: White barium matte glaze,
CuCr barium matte glaze, cone 6 oxidation
firing in an electric kiln

w 11 × h 7 inches
w 28 × h 18 centimeters

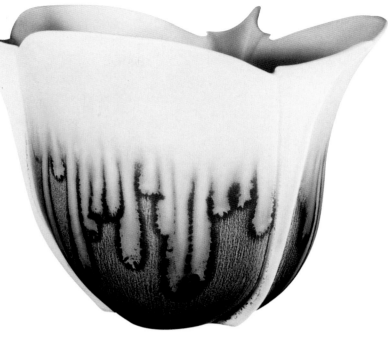

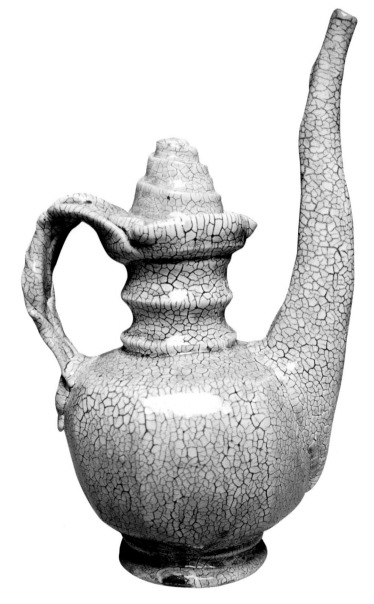

CLARK BURGAN
Ewer

Thrown stoneware
Glaze and Firing: Cone 10 soda firing

w 7 × h 15 × d 10 inches
w 18 × h × 38 d 25 centimeters

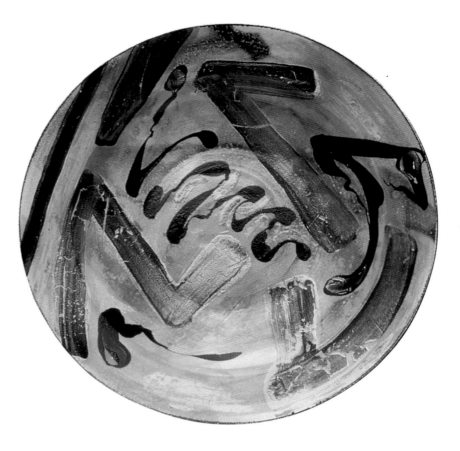

HUNT PROTHRO
Porcelain platter

Thrown porcelain
Glaze and Firing: Underglazes, stains,
cone 10 reduction firing

w 24 × h 4 × d 24 inches
w 61 × h 10 × d 61 inches

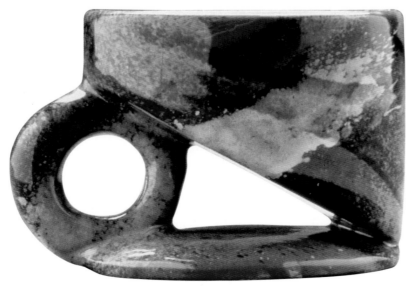

CHARLES B. NALLE
Half a Cup

Cast semi-vitreous, high-fire porcelain
Glaze and Firing: Layered opaque glazes,
oxidation firing

w 3 × h 3 × d 3 inches
w 8 × h 8 × d 8 centimeters

Slab-molded porcelain
Glaze and Firing: Cone 10 reduction glazes,
resist, oxide stains, firing to cone 10 in a
reduction atmosphere in a gas downdraft kiln

w 13 × h 10 × d 2 inches
w 33 × h 25 × d 5 centimeters

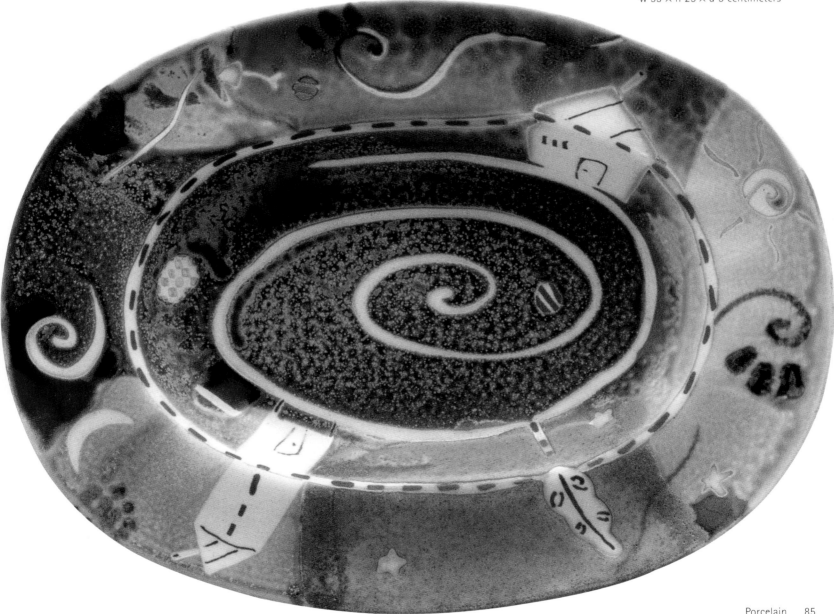

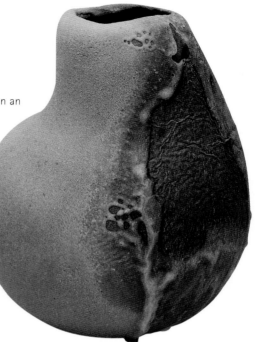

LOLA J. LOGSDON
#9306

Thrown and altered earthenware
Glaze and Firing: Glazes, cone 04 firing in an
electric kiln

w 7.5 × h 9.75 × d 7.5 inches
w 19 × h 25 × d 19 centimeters

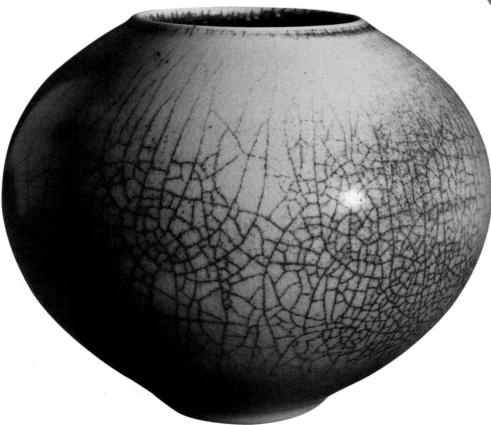

MARK BELL
Porcelain Vase #831

Porcelain
Glaze and Firing: Celadon glaze, oxidation
firing, cone 10 reduction firing

w 8 × h 8 × d 8 inches
w 20 × h 20 × d 20 centimeters

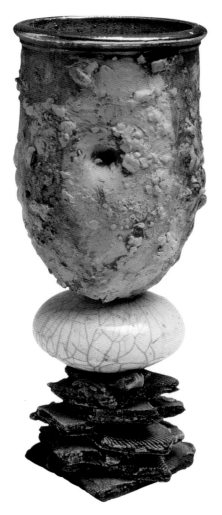

STANTON HUNTER
Craggy goblet

Thrown, slab-built, and epoxied porcelain
Glaze and Firing: Crackle glaze, smoke
cup-slip, oxides, ash glaze, luster, raku
firing on base, cone 10 reduction/luster
fire to cone 019 on base

w 3 × h 8 × d 3 inches
w 8 × h 20 × d 8 centimeters

JENNIFER A. HILL
Sugar with creamer

Thrown and ovaled porcelain
Glaze and Firing: Deep green, copper red, and
blue glaze, cone 10 reduction firing

w 4 × h 3 × d 10 inches
w 10 × h 8 × d 25 centimeters

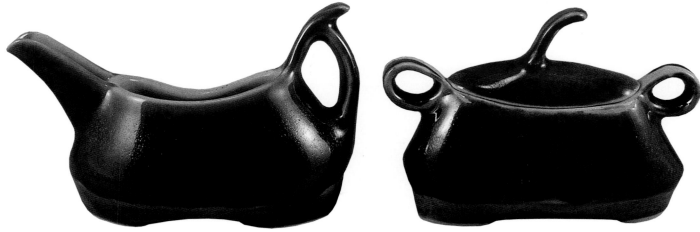

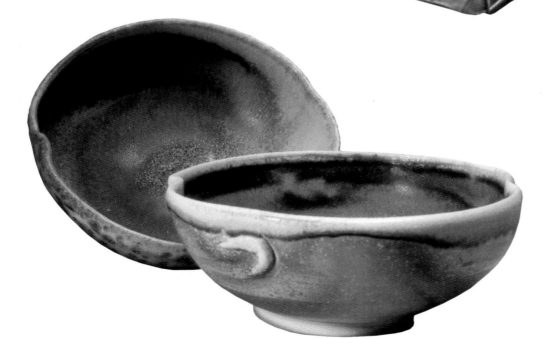

BONNIE SEEMAN
Cup, saucer, and base

Thrown and hand-built porcelain
Glaze and Firing: Airbrushed glazes, brushed
gold luster, cone 10 oxidation firing, cone 018
gold luster firing

w 12 × h 7 × d 10 inches
w 30 × h 18 × d 25 centimeters

CAROL B. EDER
Fluid Clay series: soup bowls

Thrown and altered porcelain
Glaze and Firing: Brushed, temoku, shino, and
copper stains, firing in an anagama wood kiln

w 4 × h 7 × d 4 inches
w 10 × h 18 × d 10 centimeters

photo: Joseph Gruber

NICOLETTE MITCHELL
Up on the Horizon

Hand-built and press-molded porcelain
Glaze and Firing: Cone 03 oxidation firing in an
electric kiln

w 12 × h 11 × d 5 inches
w 30 × h 28 × d 13 centimeters

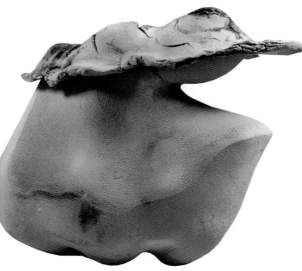

DALE HUFFMAN
Ochoko

Thrown porcelain
Glaze and Firing: Shino,
cone 9 reduction firing

w 3.39 × h 2 × d 2 inches
w 9 × h 5 × d 5 centimeters

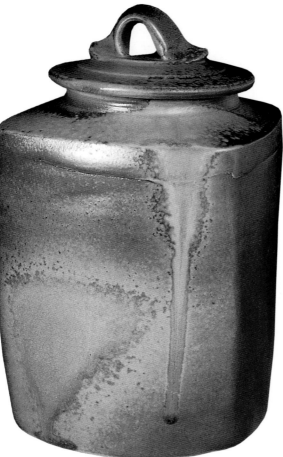

PEG MALLOY
Square-lidded jar

Thrown and altered porcelain
Glaze and Firing: Shino slip, wood
firing in a bourry box kiln

w 6.5 × h 9.5 × d 6.5 inches
w 17 × h 24 × d 17 centimeters

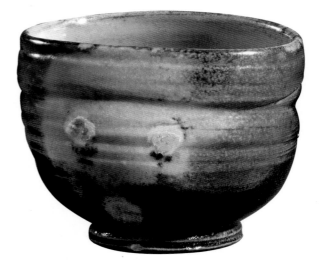

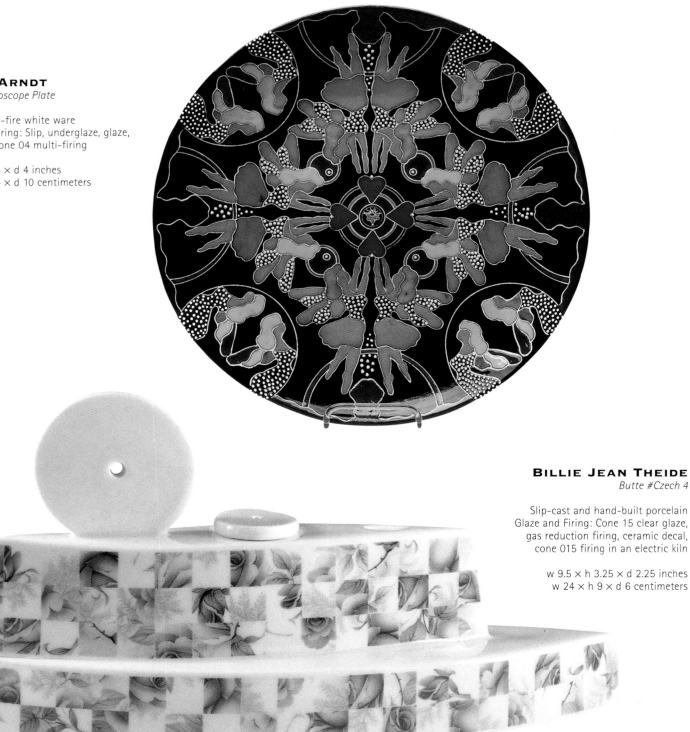

LINDA ARNDT
Fairy Kaleidoscope Plate

Thrown, low-fire white ware
Glaze and Firing: Slip, underglaze, glaze,
overglaze, cone 04 multi-firing

w 25 × h 25 × d 4 inches
w 64 × h 64 × d 10 centimeters

BILLIE JEAN THEIDE
Butte #Czech 4

Slip-cast and hand-built porcelain
Glaze and Firing: Cone 15 clear glaze,
gas reduction firing, ceramic decal,
cone 015 firing in an electric kiln

w 9.5 × h 3.25 × d 2.25 inches
w 24 × h 9 × d 6 centimeters

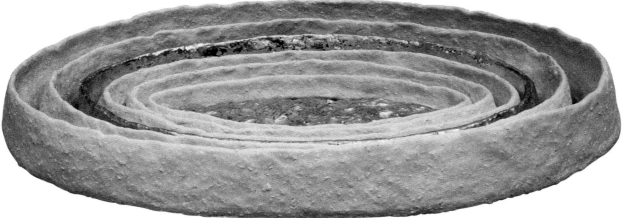

MARIA BOFILL
Labyrinth

Hand-built porcelain
Glaze and Firing: Gas reduction
firing at 1280°C

w 14.5 × h 1.5 × d 10.25 inches
w 37 × h 4 × d 26 centimeters

NEIL PATTERSON
Set of potion bottles

Thrown and assembled porcelain
Glaze and Firing: Celadons, matte
glazes, ash glaze, cone 10 reduction
firing in a gas kiln

w 3 × h 6 × d 3 inches
w 8 × h 15 × d 8 centimeters

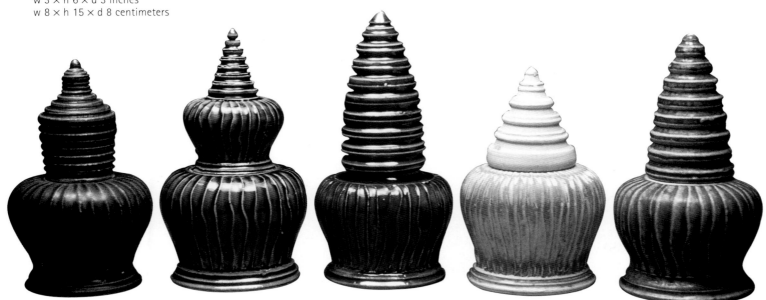

CLIFF LEE
Cabbage vase on pedestal

Thrown porcelain
Glaze and Firing: Celadon, reduction firing

w 10.5 × h 10.75 inches
w 27 × h 28 centimeters

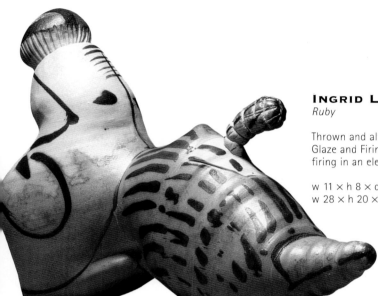

INGRID LILLIGREN
Ruby

Thrown and altered porcelain
Glaze and Firing: Salted porcelain, cone 10
firing in an electric kiln

w 11 × h 8 × d 4 inches
w 28 × h 20 × d 10 centimeters

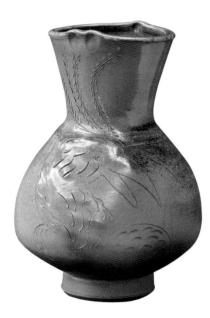

VINCENT SUEZ
Flight series

Thrown porcelain
Glaze and Firing: Ash glaze,
cone 12 wood firing

w 11 × h 18 × d 11 inches
w 28 × h 46 × d 28 centimeters

SHANNON NELSON
Bowl About Softness

Thrown and altered porcelaneous stoneware
Glaze and Firing: Glaze, cone 10 reduction firing

w 6.5 × h 3 × d 6 inches
w 17 × h 8 × d 15 centimeters

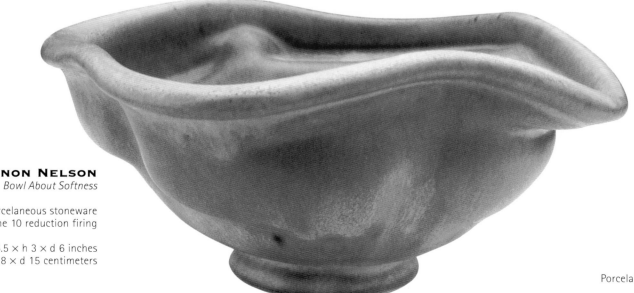

DICK LEHMAN
Thank You, Malcolm

Thrown, altered, and assembled grolleg porcelain
Glaze and Firing: Carbon-trapping glaze, cone 10
firing in a wood sagger kiln

w 5.5 × h 12.25 × d 5 inches
w 14 × h 32 × d 14 centimeters

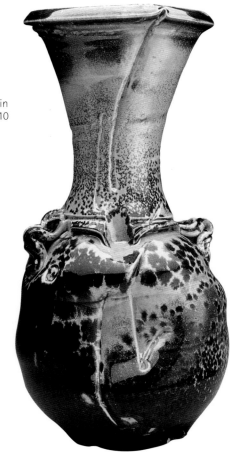

GEOFFREY WHEELER
Teapot

Thrown, hand-built, and assembled porcelain
Glaze and Firing: Sprayed copper glazes, cone 10
soda firing

w 8 × h 9 × d 5 inches
w 20 × h 23 × d 13 centimeters

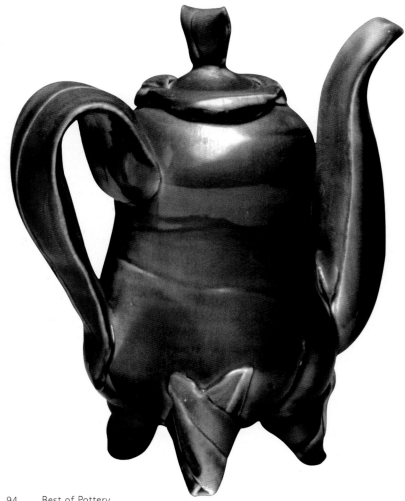

EVE FLECK
Platter

Slab-built porcelain
Glaze and Firing: Clear glaze, underglaze,
sgraffito, cone 7 oxidation firing

w 11 × h 2 × d 18 inches
w 28 × h 5 × d 46 centimeters

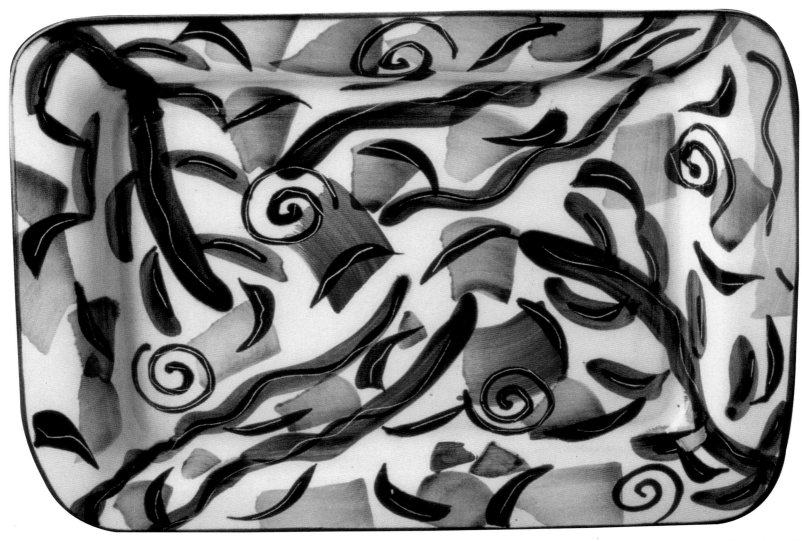

HIDEAKI MIYAMURA
Covered jar

Thrown porcelain
Glaze and Firing: White crackle glaze, cone 10
oxidation firing

w 12.25 × h 1 × d 12.25 inches
w 31 × h 3 × d 31 centimeters

SUSAN BEINER
Screw tea set

Molded and slip-cast porcelain
Glaze and Firing: Cone 6 oxidation, multi-firing
in gas and electric kilns

w 12 × h 21 × d 8 inches
w 30 × h 53 × d 20 centimeters

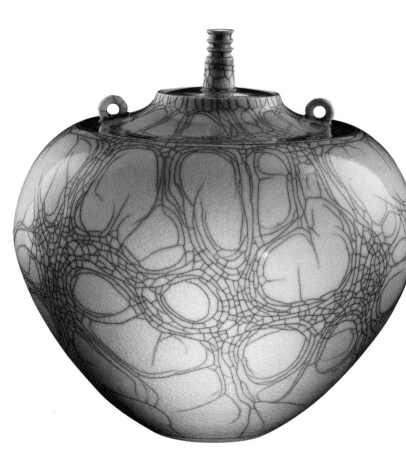

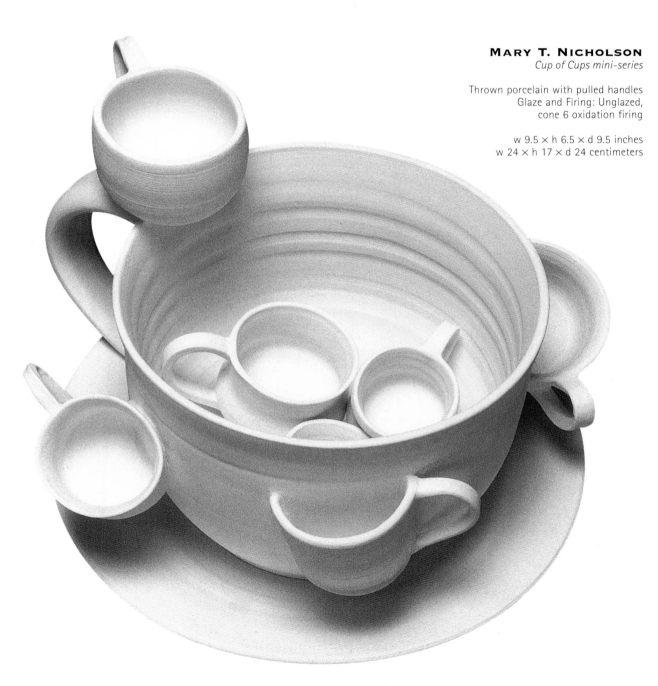

MARY T. NICHOLSON
Cup of Cups mini-series

Thrown porcelain with pulled handles
Glaze and Firing: Unglazed,
cone 6 oxidation firing

w 9.5 × h 6.5 × d 9.5 inches
w 24 × h 17 × d 24 centimeters

STONEWARE

The term "stoneware"
describes both clay composition and
firing temperature. Generally speaking,
stoneware is vitreous, glazed pottery (in which
glaze and clay have been blended together) fired
in temperature ranges from cone 6 to cone 14.
However, many potters fire their work multiple times,
using different temperatures for clay, glazes, luster,
and other embellishment. The pottery that appears
in this section was designated stoneware by the
contributing artists: the section title is
intended only in its broadest sense.

ERIC NELSEN
Bust Series: Tea Ceremony

Hand-built, press-molded, coil-built, and thrown
stoneware
Glaze and Firing: Unglazed, natural fly ash
deposit, cone 14 firing in an anagama wood kiln

w 24 × h 26 × d 14 inches
w 61 × h 66 × d 36 centimeters

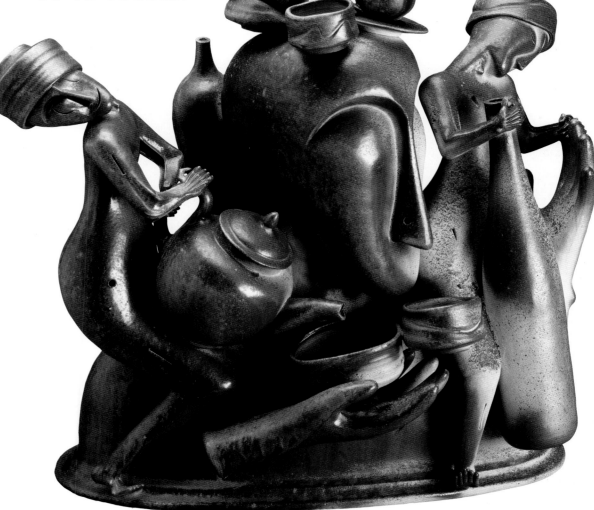

WINTHROP BYERS
Copper Red Platter #3

Thrown stoneware
Glaze and Firing: Airbrushed iron and
copper glazes, cone 11 reduction firing
in natural gas ceramic fiber kiln

w 15 × h 1.5 inches
w 38 × h 4 centimeters

RONALD LARSEN
Sake set

Thrown, altered, and fluted stoneware
Glaze and Firing: Ash-like copper glaze,
cone 10 firing

w 5 × h 5 × d 6 inches
w 13 × h 13 × d 15 centimeters

RIMAS VISGIRDA
Smoking Woman with Baseball Cap Teapot

Thrown and altered stoneware
Glaze and Firing: Cone 10 oxidation firing, cone
10 engobes, cone 05 pencil glazes, cone 018
glaze, lusters, cone 05 oxidation firing, cone
018 oxidation firing

w 9 × h 9 × d 5 inches
w 23 × h 23 × d 13 centimeters

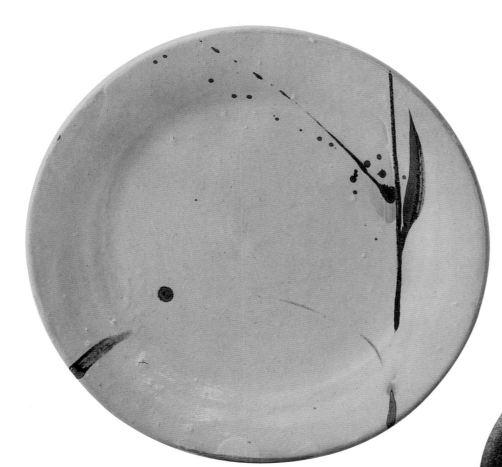

CATHERINE WHITE
Plate with glass pattern

Thrown white stoneware
Glaze and Firing: White slip, iron brushwork,
celadon glaze, gas firing

w 11 × h 1.5 × d 11 inches
w 28 × h 4 × d 28 centimeters

STEVEN HILL
Cypress ewer

Thrown and altered stoneware body with pulled
handle and spout
Glaze and Firing: Sprayed glazes, cone 10 gas
reduction firing

w 11 × h 19 × d 7 inches
w 28 × h 48 × d 18 centimeters

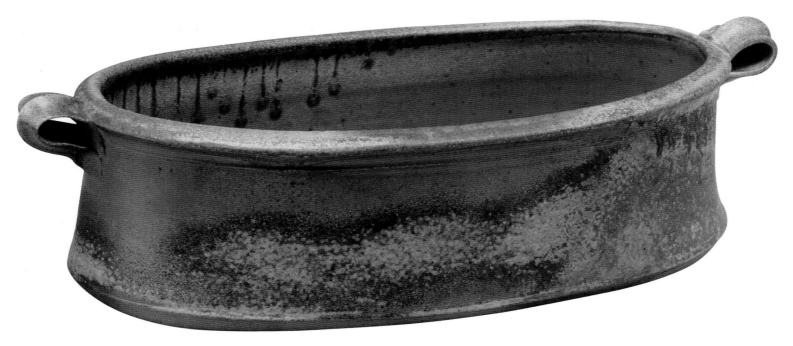

DAN EDMUNDS
Teapot

Hand-built stoneware
Glaze and Firing: Slips, black glaze, wood
firing with salt

w 2 × h 9 × d 7 inches
w 5 × h 23 × d 18 centimeters

BILL GRIFFITH
Oval casserole

Thrown and altered stoneware
Glaze and Firing: Shino glazed interior,
natural ash glazed exterior, firing in an
anagama wood kiln

w 12 × h 5 × d 6 inches
w 30 × h 13 × d 15 centimeters

DAN FINNEGAN
Mug

Thrown stoneware
Glaze and Firing: Ash glaze, crackle slip,
wood fired with light salt

w 4 × h 5 × d 4 inches
w 10 × h 13 × d 10 centimeters

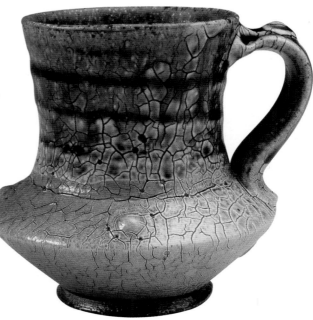

DICK LEHMAN
Whiskey for Three

Thrown and altered stoneware
Glaze and Firing: Natural ash glaze,
cone 12 wood firing

w 3.25 × h 4 × d 2.5 inches
w 9 × h 10 × d 6 centimeters

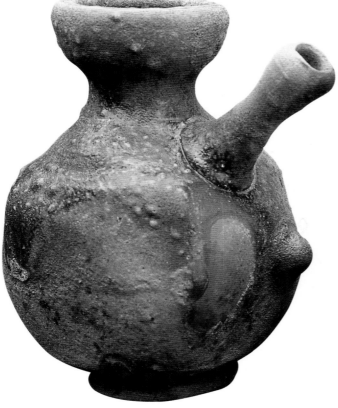

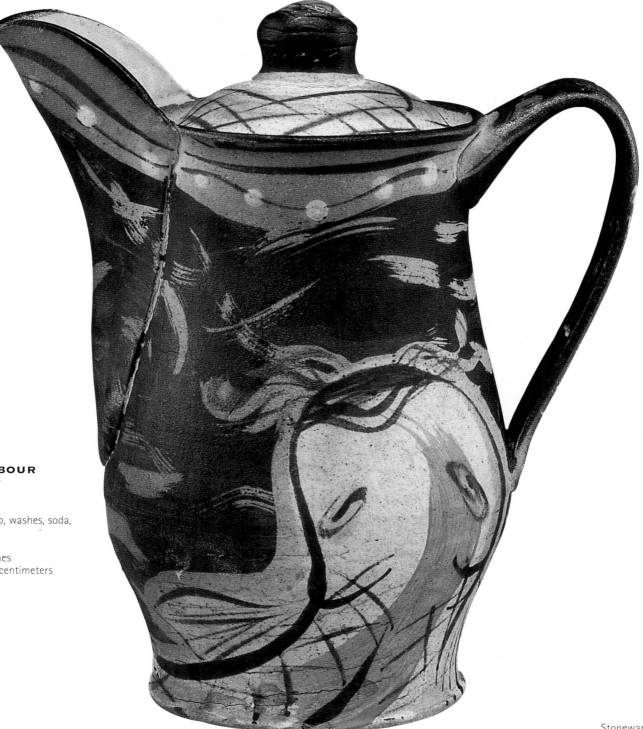

NANCY BARBOUR
Catfish coffee server

Thrown stoneware
Glaze and Firing: Slip, washes, soda,
wood firing

w 7 × h 8 × d 4 inches
w 18 × h 20 × d 10 centimeters

BRAD SCHWIEGER
Slab-fired teapot

Thrown and altered stoneware body with
press-molded spout and handle
Glaze and Firing: Salt glaze, slips,
cone 9 reduction firing with salt

w 11 × h 23 × d 6 inches
w 28 × h 58 × d 15 centimeters

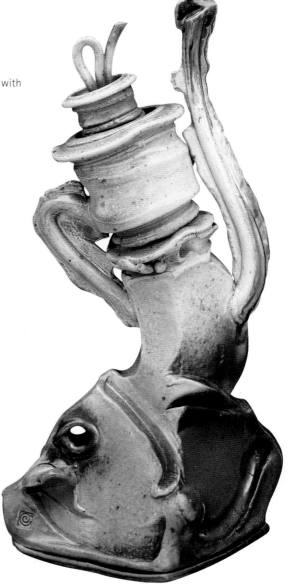

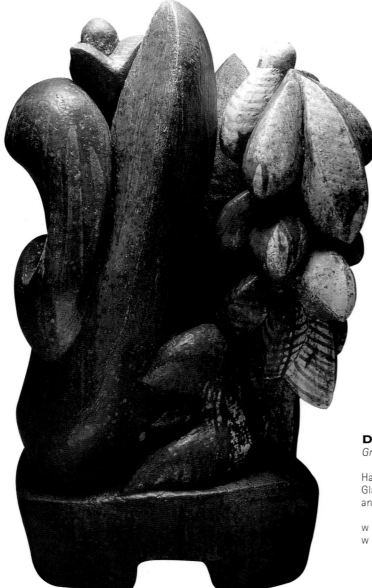

D. LESLIE FERST
Grotto 43 series

Hand-built, carved, and assembled stoneware
Glaze and Firing: Underglaze engobes
and glaze wash, cone 9 reduction firing

w 26 × h 42 × d 26 inches
w 66 × h 107 × d 66 centimeters

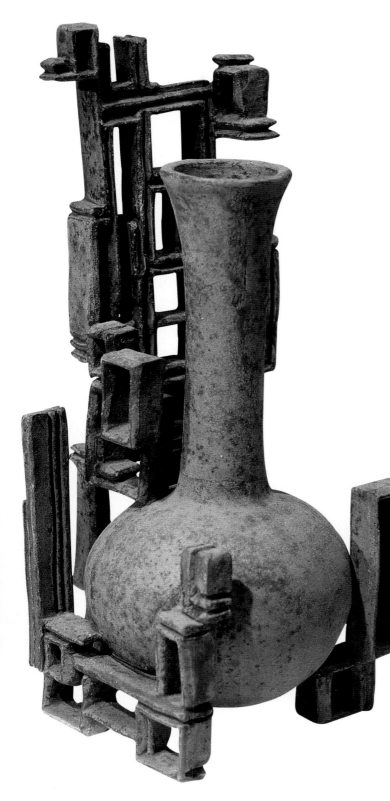

MIKA NEGISHI
Me, Myself, and I

Hand-built stoneware
Glaze and Firing: Sprayed cone 1 glazes,
firing in an electric kiln

w 16 × h 24 × d 13 inches
w 41 × h 61 × d 33 centimeters

RAGNAR NAESS
Chinese bud vase

Thrown, slab-incised, constructed, and carved
stoneware
Glaze and Firing: Oxidation firing in gas and
electric kilns

w 4.5 × h 10.25 × d 4.5 inches
w 11 × h 26 × d 11 centimeters

PAUL A. MENCHHOFER
Water Jar

Thrown stoneware
Glaze and Firing: Sprayed multiple
raku glazes, multi-firing in a raku car kiln

h 21 × d 28 inches
h 53 × d 71 centimeters

LEN EICHLER
Pile-up

Thrown stoneware assembled in mold
Glaze and Firing: Iron oxide stain,
cone 6 oxidation firing

w 6 × h 9 × d 6 inches
w 15 × h 23 × d 15 centimeters

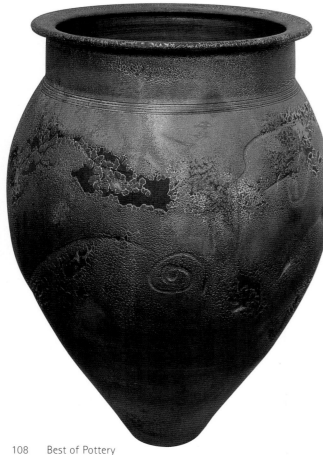

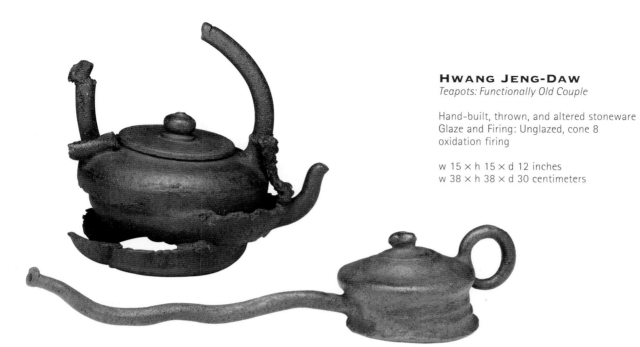

HWANG JENG-DAW
Teapots: Functionally Old Couple

Hand-built, thrown, and altered stoneware
Glaze and Firing: Unglazed, cone 8
oxidation firing

w 15 × h 15 × d 12 inches
w 38 × h 38 × d 30 centimeters

KEN BICHELL
Thrown stoneware

Glaze and Firing: Fly ash glaze,
seven-day firing in an anagama
wood kiln

w 15 × h 10 × d 1 inches
w 38 × h 25 × d 3 centimeters

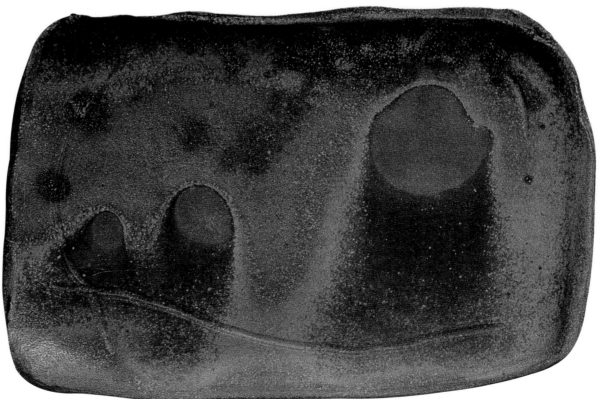

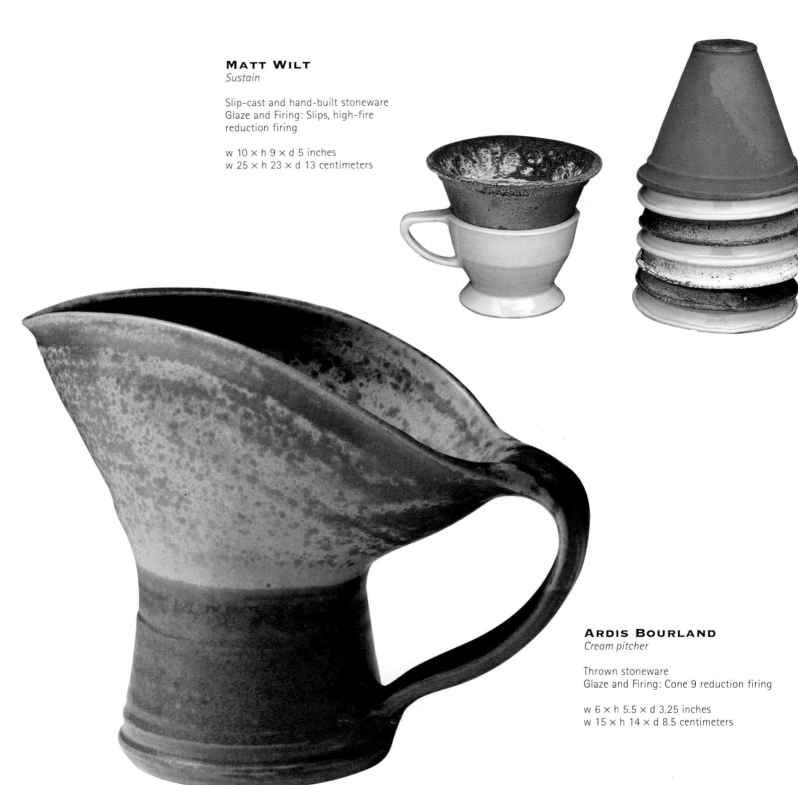

MATT WILT
Sustain

Slip-cast and hand-built stoneware
Glaze and Firing: Slips, high-fire
reduction firing

w 10 × h 9 × d 5 inches
w 25 × h 23 × d 13 centimeters

ARDIS BOURLAND
Cream pitcher

Thrown stoneware
Glaze and Firing: Cone 9 reduction firing

w 6 × h 5.5 × d 3.25 inches
w 15 × h 14 × d 8.5 centimeters

YVONNE KLEINVELD
S-vase

Stoneware
Glaze and Firing: Sinter engobe exterior; glazed
interior, firing to 1160˚C in a gas kiln

w 4 × h 12 × d 4 inches
w 10 × h 30 × d 10 cm

PAUL HEROUX
4

Thrown porcelaneous stoneware
Glaze and Firing: Cone 10 glazes and oxides, wax
resist, cone 10 reduction firing

w 22 × h 5 × d 22 inches
w 56 × h 13 × d 56 centimeters

BRUCE M. WINN
Bottle form

Slab-built white stoneware
Glaze and Firing: Wax resist, inlayed glaze,
cone 10 oxidation firing in an electric kiln

w 10 × h 24 × d 10 inches
w 25 × h 61 × d 25 centimeters

SAM TAYLOR
Pocketbook Teapot with Square Cups

Thrown and altered stoneware
Glaze and Firing: Copper glaze, wood firing

w 6 × h 12 × d 2 inches
w 15 × h 30 × d 5 centimeters

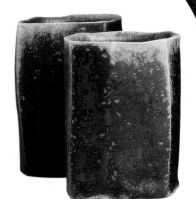

JEFF OESTREICH
Beaked pitcher

Thrown stoneware
Glaze and Firing: Dipped, salt glazed

w 10 × h 10 × d 4 inches
w 25 × h 25 × d 10 centimeters

FRANK PITCHER
Pitcher

Thrown and altered stoneware
with pulled handle
Glaze and Firing: Slip, gray liner glaze,
cone 10 salt firing

w 6.5 × h 7.5 × d 5 inches
w 17 × h 19 × d 13 centimeters

GEORGE BAKER
Frog Teapot 1

Thrown and hand-built stoneware
Glaze and Firing: Oxide colored slips,
oxidation firing

w 14 × h 24 × d 8 inches
w 36 × h 61 × d 20 centimeters

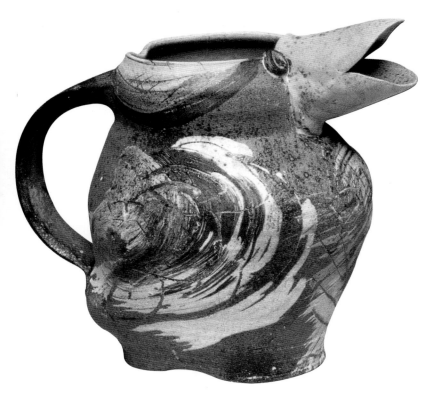

JOHN KANTAR
Bird pitcher

Thrown, altered, and hand-built stoneware
Glaze and Firing: Sgraffito, engobe,
soda, gas firing

w 10.5 × h 9 × d 6.75 inches
w 27 × h 23 × d 18 centimeters

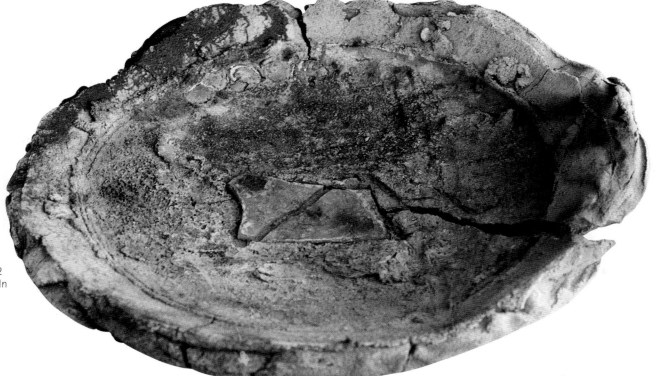

HILDA MEROM
Sagger plate

Thrown and altered stoneware
Glaze and Firing: Unglazed, cone 2
reduction firing in a gas sagger kiln

d 18.5 inches
d 47 centimeters

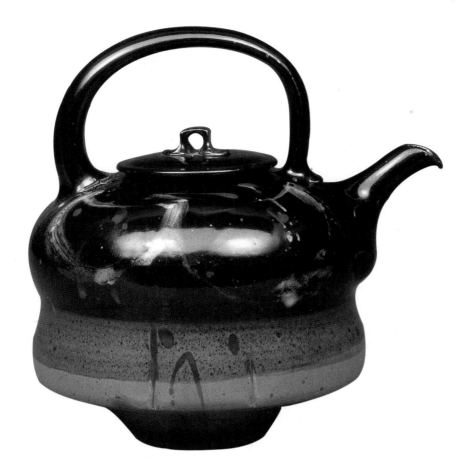

ROBERT WOO
Teapot

Thrown and assembled stoneware
Glaze and Firing: Layered glazes, trailed and
brushed glazes and washes, reduction firing

w 9 × h 11 inches
w 23 × h 28 centimeters

MICHAEL G. ROSEBERRY AND
BRUCE M. WINN
Cup and saucers

Slab-built white stoneware
Glaze and Firing: Cone 6 oxidation firing in an
electric kiln

w 7 × h 4 × d 5 inches
w 18 × h 10 × d 13 centimeters

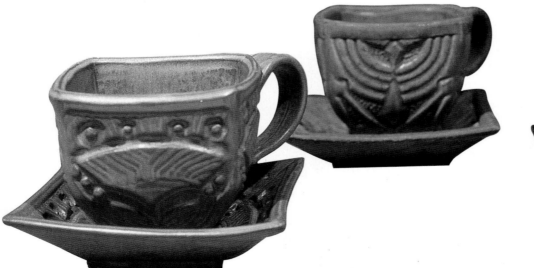

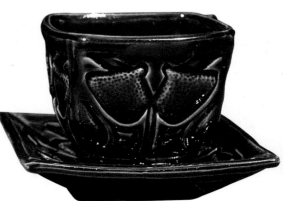

STEFFANIE SAMUELS
Leaf, Woman, and Sun

Slab- and coil-built stoneware
Glaze and Firing: Brushed porcelain slip,
glaze, oil paint, cone 8 oxidation firing
in an electric kiln

d 23 inches
d 58 centimeters

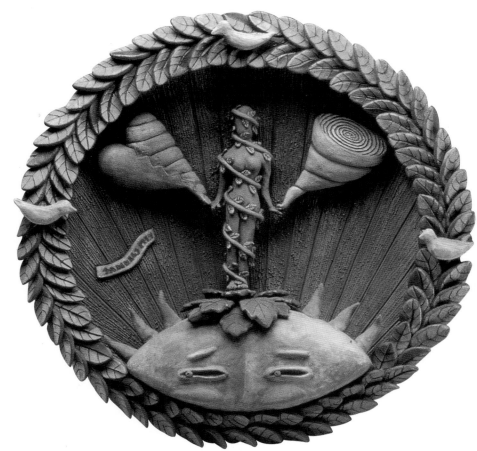

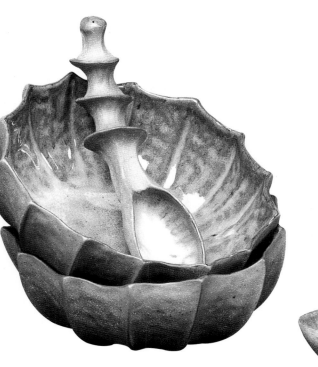

BARBARA WALCH
Bowls and spoons

Pinched and hand-built stoneware
Glaze and Firing: Unglazed exterior,
iron and cobalt blue glazed interior,
cone 10 reduction firing

w 6 × h 2 × d 6 inches
w 15 × h 5 × d 15 centimeters

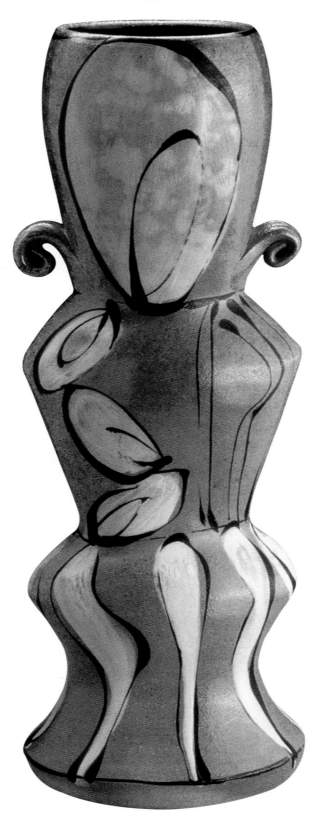

SUZE LINDSAY
Bouquet Vase

Thrown, altered, and stacked stoneware
Glaze and Firing: Slips, cone 10 salt firing

w 3 × h 14 × d 3.5 inches
w 8 × h 36 × d 9 centimeters

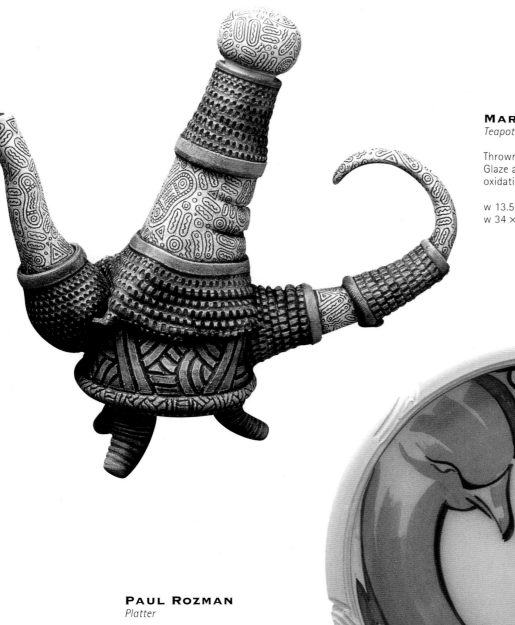

MARKO FIELDS
Teapot for the Tactile Impaired

Thrown and altered stoneware and porcelain
Glaze and Firing: Underglaze, clear glaze, cone 7
oxidation firing

w 13.5 × h 13 × d 6 inches
w 34 × h 33 × d 15 centimeters

PAUL ROZMAN
Platter

Thrown stoneware
Glaze and Firing: Titanium matte glaze,
stains, cone 6 oxidation firing

d 14 inches
d 36 centimeters

PATRICK TUDDY
Salvage-Yard Teapot

Hand-built, slab-built, and press-molded
stoneware
Glaze and Firing: Sprayed glaze, cone 10
reduction firing

w 5 × h 15 × d 24 inches
w 12 × h 38 × d 61 centimeters

BARBARA KNUTSON
Casserole

Hand-built stoneware
Glaze and Firing: Copper/cobalt green glaze,
cobalt green matte glaze, cone 10 reduction
firing

w 9.5 × h 5.5 × d 4.5 inches
w 24 × h 14 × d 11 centimeters

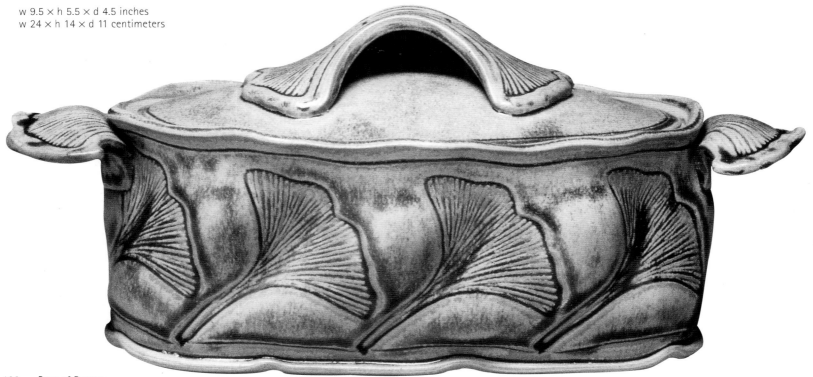

SUSAN O'BRIEN
Sauce boat

Thrown and slab-built stoneware
Glaze and Firing: Cone 10 alkaline and
celadon, lusters, cone 10 soda oxidation
firing/luster firing

w 7 × h 5 × d 4 inches
w 18 × h 13 × d 10 centimeters

BACIA EDELMAN
Lichen Teapot XII

Hand-built stoneware
Glaze and Firing: Layered surfaces, underglazes,
terra sigillata, cone 6 lichen glaze, multi-firing in
an electric kiln

w 14 × h 12.5 × d 4.5 inches
w 36 × h 32 × d 11 centimeters

ROBERT WINOKUR
Pitcher

Slip-cast stoneware from molds
Glaze and Firing: Blue wood ash glaze, slips,
engobes, salt glazes

w 10.75 × h 10.75 × d 5 inches
w 28 × h 28 × d 13 centimeters

CHRIS STALEY
4 cups

Thrown and altered stoneware
Glaze and Firing: Slips, residual salt

w 12 × h 10 × d 12 inches
w 30 × h 25 × d 30 centimeters

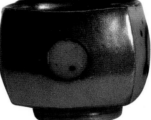

LANA WILSON
Ritual teapot

Hand-built stoneware slabs with
hand-made stamps
Glaze and Firing: Layered glazes and engobes,
cone 6 firing in an electric kiln

w 15 × h 8 × d 5 inches
w 38 × h 20 × d 13 centimeters

CHUCK SOLBERG
Ashen jug

Thrown, faceted, and distorted stoneware
Glaze and Firing: Natural ash, four-day
firing in an anagama wood kiln

w 8 × h 12 × d 6 inches
w 20 × h 30 × d 15 centimeters

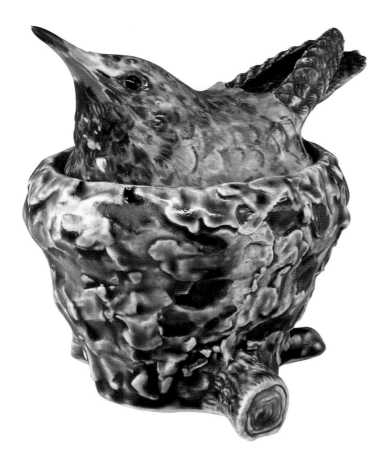

SANDRA L. LANCE
Nesting Bird Jar

Thrown, altered, modeled, and carved white
mid-range stoneware
Glaze and Firing: Underglazes, colored
translucent and satin glazes, cone 6
oxidation firing

w 5.25 × h 5 × d 4 inches
w 13 × h 13 × d 10 centimeters

NICKIE MALY AZICRI
Thorn Mother

Hand-built stoneware
Glaze and Firing: Glazes mixed with sand,
low-fire firing

w 19.5 × h 18 × d 16 inches
w 50 × h 46 × d 41 centimeters

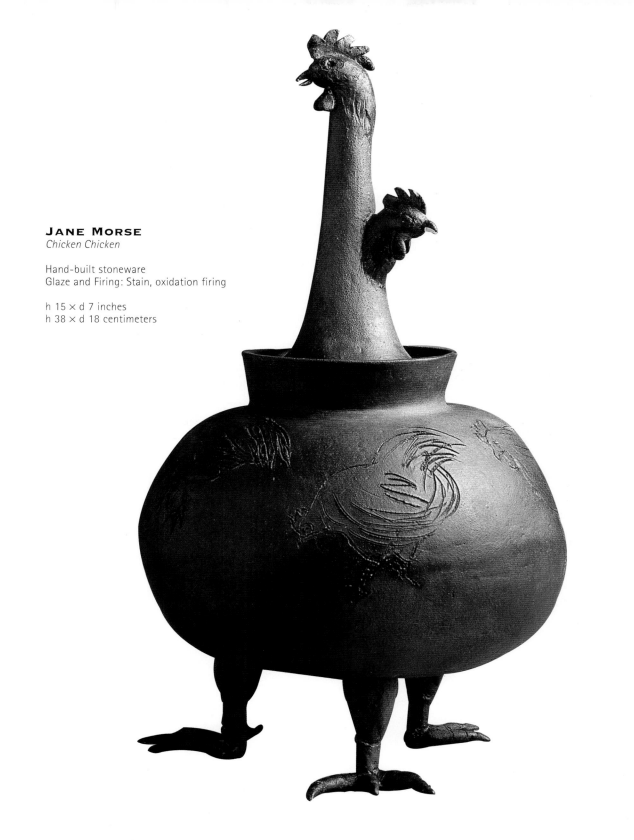

JANE MORSE
Chicken Chicken

Hand-built stoneware
Glaze and Firing: Stain, oxidation firing

h 15 × d 7 inches
h 38 × d 18 centimeters

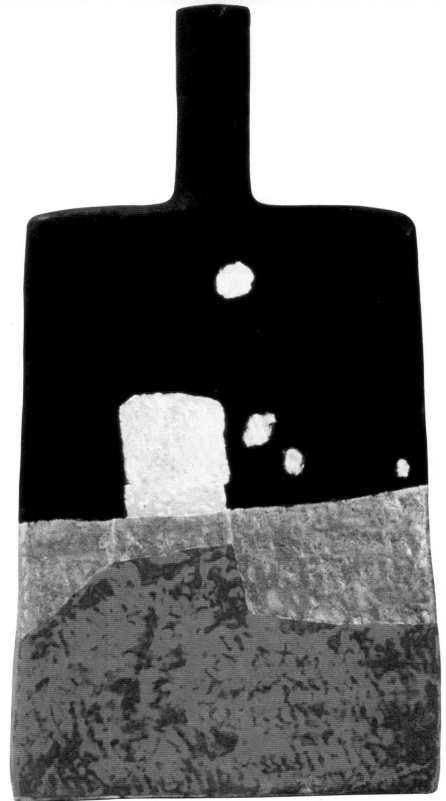

WALTER DEXTER
Urban Landscape

Hand-built stoneware
Glaze and Firing: Black and white stoneware,
slip, lithium orange glaze, chrome-red glaze,
cone 6 gas and cone 08 multi-firing

w 18 × h 32 × d 4 inches
w 46 × h 81 × d 10 centimeters

MARY BARRINGER
Teapot

Hand-built stoneware
Glaze and Firing: Layered slip, glazes, cone 6
firing in an electric kiln

w 9.5 × h 9.5 × d 4.5 inches
w 24 × h 24 × d 11 centimeters

MARK JOHNSON
Teapot with stripes

Thrown and altered white stoneware
Glaze and Firing: Glazes, wax and latex resists,
cone 10 soda firing

w 10 × h 15 × d 10 inches
w 25 × h 38 × d 25 centimeters

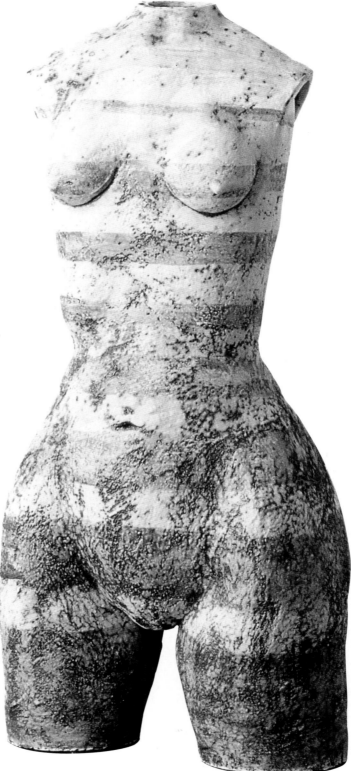

JANET HARBOTTLE
Striped Torso

Hand-built stoneware
Glaze and Firing: Layered slips, low-fire glaze,
cone 04 firing in an electric kiln

w 9.5 × h 19.5 × d 7 inches
w 24 × h 50 × d 18 centimeters

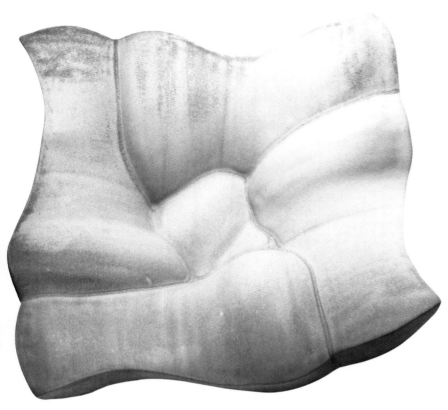

ERICA WURTZ
Dulcet

Thrown and hand-built stoneware
Glaze and Firing: Cone 9 reduction firing

w 14 × h 4 × d 10 inches
w 36 × h 10 × d 25 centimeters

ANN M. TUBBS
Lemons and Blue Wave

Slab-built stoneware
Glaze and Firing: High-fire majolica glaze,
cone 3 and cone 4 oxidation firing in an
electric kiln

w 18 × h 1.75 × d 11 inches
w 46 × h 5 × d 28 centimeters

RAVIT BIRENBOIM
Untitled

Hand-built stoneware on a bisque mold
Glaze and Firing: Henderson glaze,
oxidation firing

w 5–7 × h 2–3 × d 3–4 inches
w 13–18 × h 5–8 × d 8–10 centimeters

MALCOLM E. KUCHARSKI
Covered jar

Thrown and hand-built stoneware
Glaze and Firing: Feldspathic glaze, cone 9
reduction firing

w 24 × h 27 × d 12 inches
w 61 × h 69 × d 30 centimeters

MIKE LEMKE
Window

Thrown, hand-built, and slab-built stoneware
Glaze and Firing: Sprayed and brushed glazes,
low-temperature firing in an electric kiln

w 9 × h 8 inches
w 23 × h 20 centimeters

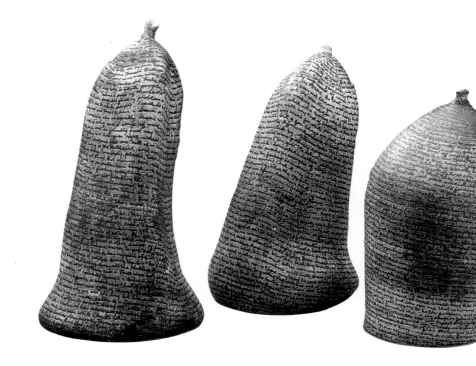

BRUCE A. BARRY
Journal Entry #54, Journal Entry #55, Journal Entry #59

Thrown and altered stoneware
Glaze and Firing: Mason stains, cone 10
reduction glazes, cone 10 reduction firing

h 16, 14.5, 13 inches
h 46, 36, 33 centimeters

SUSAN BEECHER
Tall jar

Thrown stoneware
Glaze and Firing: Wood ash glaze with rutile,
wood firing for 16 hours with salt added

w 7 × h 23 × d 5 inches
w 18 × h 58 × d 13 centimeters

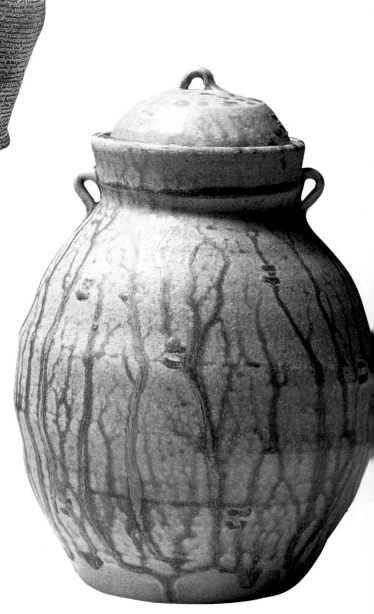

SUSAN EISEN
Vortex

Hand-built, coil-built, and slab-built stoneware
Glaze and Firing: Oxides washes and stains,
cone 10 oxidation firing

w 23 × h 16 × d 17 inches
w 58 × h 41 × d 43 centimeters

INGE GYRITE BALCH
Fossil Fuel environment series #6

Hand-built and assembled stoneware
Glaze and Firing: Oxides, low-fire glazes,
cone 3 and cone 05 firing

w 28 × h 18 × d 7 inches
w 71 × h 46 × d 18 centimeters

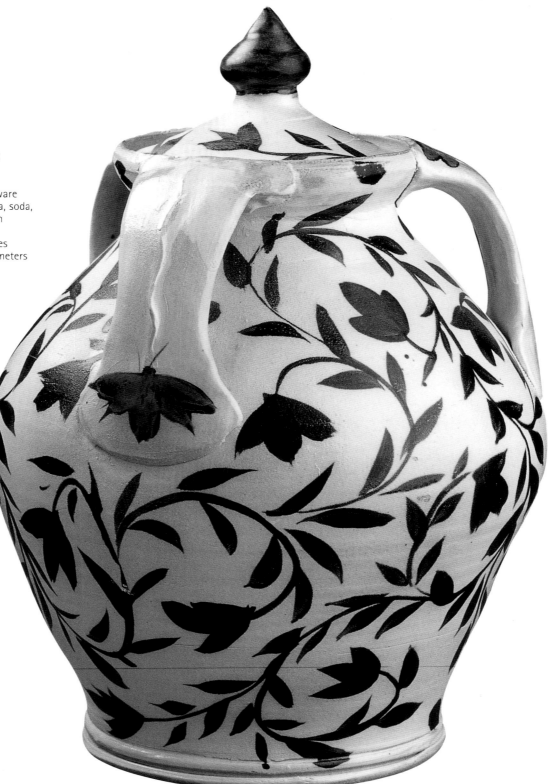

MICHAEL KLINE
Jar with black vines

Thrown and pulled stoneware
Glaze and Firing: Salt/soda, soda,
cone 11 firing in a gas kiln

w 9.5 × h 18 × d 9.5 inches
w 24 × h 46 × d 24 centimeters

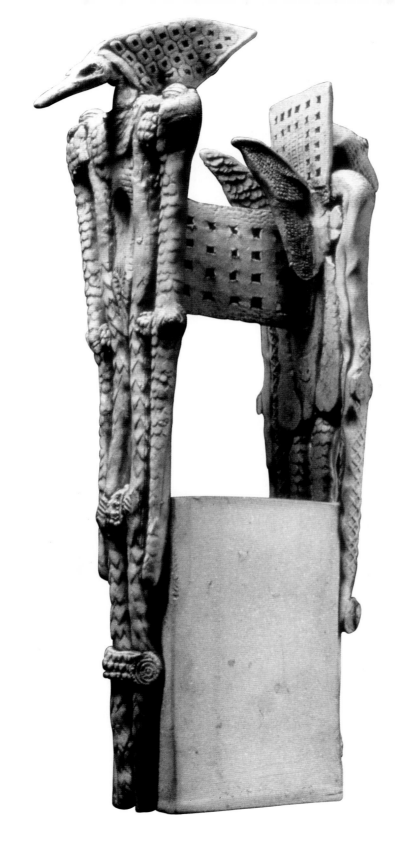

MICHAEL COHEN
Two figures guarding vase

Hand- and slab-built stoneware
Glaze and Firing: Black wash, cone 10
reduction firing

w 5 × h 26 × d 7 inches
w 13 × h 66 × d 18 centimeters

MARVIN SWEET
Animistic pitcher

Hand-built stoneware
Glaze and Firing: Poured and
brushed glazes, raku firing

w 12 × h 11 × d 4 inches
w 30 × h 28 × d 10 centimeters

HIROSHI NAKAYAMA
Ceremonial vessel

Thrown, slab-built, altered, and
assembled stoneware
Glaze and Firing: Layered wood ash base glazes,
cone 10 reduction multi-firing

w 12 × h 3 × d 12 inches
w 30 × h 8 × d 30 centimeters

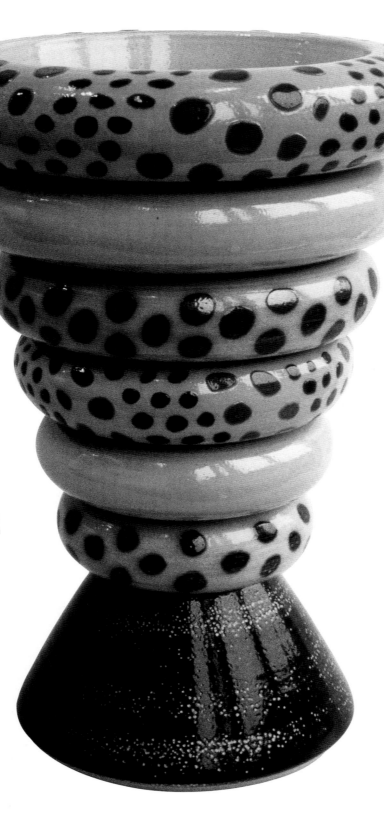

PAULIEN PLOEGER
Radix

Thrown and assembled stoneware
Glaze and Firing: Salt glaze, colored slips, latex
resists, neutral/light reduction firing in gas kiln

h 15.75 inches
h 40 centimeters

ABOUT THE JUDGES

ANGELA FINA

Angela Fina received a Master of Fine Arts from the School for American Craftsmen at the Rochester Institute of Technology. A teacher and artist, she taught ceramics at colleges in New York and Canada for sixteen years. After a year as an invited resident artist at the Penland School of Crafts, she set up a professional studio in Amherst, Massachusetts. A self-supporting potter for seventeen years, Fina works in porcelain and specializes in high-temperature reduction glazes. Her work includes thrown tableware and containers for Japanese flower arranging, and is shown in galleries, museum shops, and invitational shows all over the United States. She teaches workshops in porcelain and glaze technology, and has served on many craft show juries.

"I want my work to be used in the home to enhance the everyday acts of serving food and displaying flowers. My concerns are unobtrusive functionality, elegant forms, and beautiful color."
—Angela Fina

CHRISTOPHER GUSTIN

Christopher Gustin attended the Kansas City Art Institute, from which he received his BFA in 1975, and the New York State College of Ceramics at Alfred University, where he received his MFA in 1977. Gustin began his teaching career in 1978 at Parsons School of Design in New York. In 1980, he joined the faculty at the Program in Artisanry at Boston University, and in 1985, the program moved to the Swain School of Design in New Bedford. He has been Associate Professor of Ceramics and Design at the University of Massachusetts, Dartmouth, since 1988. After twenty years of teaching, he is retiring from academia to devote his full time energies to his studio work. Gustin has presented many workshops and lectures throughout the United States and abroad, and his work is published extensively. He has had numerous exhibitions, and is represented in many public and private collections, including the Los Angeles County Museum of Art; the Victoria and Albert Museum, London; the Shigaraki Museum of Art, Japan; the Everson Museum of Art; the Rhode Island School of Design Art Museum; the Mint Museum of Art; and the Wustum Museum of Fine Art. He has received two National Endowment for the Arts Artists Fellowships, and the Massachusetts Crafts Fellowship from the Artists Foundation.

"My interest is in pots that make connections to the human figure, and the innate social need to touch. The pots that I respond to in history all speak to a clear, direct sense of the hand. The work celebrates the hand, and it is a necessary tool for the user in understanding the relationship of the object to its function."
—Christopher Gustin

DIRECTORY

Elaine Alt
28 Orne Street
Marblehead, MA 01945

Donna Anderegg
951 S. Williams
Denver, CO 80209
303/777.7864

Wesley Anderegg
951 S. Williams Street
Denver, CO 80209
303/777.7864

Stanley Mace
Andersen
Rt. 3, Box 67
Bakersville, NC 28705
704/688.2645

Nancy April
377 Sahler Mill Road
Olivebridge, NY 12461
914/657.9729

Linda Arbuckle
Rt. 1, Box 206
Micanopy, FL 32667
352/466.3520

Linda Arndt
9000 E. Susan Lane
Albany, IN 47320
765/789.4519

Elise Sheridan Arnold
P.O. Box 300
Bechtelsville, PA 19505
610/367.9756

Nickie Maly Azicri
1152 W. 6th Street
Erie, PA 16507
814/459.0168

Posey Bacopoulos
40 Fifth Avenue
New York, NY 10011
212/533.9688

George Baker
RR2, Box 1194
Athens, NY 12015
518/731.2101

Marian Baker
56 Spring Street
Yarmouth, ME 04096
207/846.1420

Inge Gyrite Balch
Baker University Art
Department
Baldwin City, KS 66006
913/594.6451 ext. 537

Nancy Barbour
604 SE 2nd Place
Gainesville, FL 32601
352/377.2533

Mary Barringer
P.O. Box 257
Shelburne Falls, MA
01370
413/339.4748

Bruce A. Barry
P.O. Box 117
Milton, MA 02186
781/696.4680

Ira Bates
3770 Selby Avenue
Los Angeles, CA
90034-6248

Susan Beecher
17 Route 23C
East Jewett, NY 12424
212/749.4756

Susan Beiner
1621 W. Hancock
Street, #2E
Detroit, MI 48208
313/833.6790

Mark Bell
P.O. Box 1074
Blue Hill, ME 04614
207/374.5881

Ken Bichell
RR2, Box 240
Fayettesville, WV
25840
304/574.3826

Jennie Bireline
228 E. Park Drive
Raleigh, NC 27605
919/833.8033

Ravit Birenboim
67-40 Booth Street,
Apt. 3C
Forest Hills, NY 11375
718/275.5277

Maria Bofill
Pl. Rius i Taulet 12
08012 Barcelona, Spain
34.3.2190670

Susan Bostwick
8615 Goshen Road
Edwardsville, IL 62025
618/656.3348

Ardis Bourland
6855 SW 45 Ln., #9
Miami, FL 33155
305/661.4371

Lynn Smiser Bowers
3715 Madison
Kansas City, MS 64111
816/561.1755

Lucy Breslin
83 Romano Road
South Portland, ME
04106
207/767.7132

Sara E. Bressem
95 Maple Street
East Longmeadow, MA
01028
413/525.4464

Regis C. Brodie
27 Wedgewood Drive
Saratoga Springs, NY
12866
518/584.5514

Shellie Z. Brooks
21 Lawrence Street
Cambridge, MA 02139
617/492.6558
Fax: 617/661.1921

Susan Meredith
Bunzl
Minor Strasse 18
81477 Munich
Germany
089/799119

Clark Burgan
470 S. 43rd Street
Boulder, CO 80303
303/554.9619

Sandra Byers
300 Pine Street
Rock Springs, WI
53961
608/522.5648

Winthrop Byers
300 Pine Street
Rock Springs, WI
53961
608/522.5648

Mary Carroll
3904 Upton Avenue
South
Minneapolis, MN
55410
612/922.8337

Henry Cavanagh
679 Lapla Road
Kingston, NY 12401
914/338.2199

Carolyn Chester
5 Sugarbush Lane
Ithaca, NY 14850
607/273.7647

Victoria D. Christen
1187 E. Knox Street
Galesburg, IL 61401
309/343.7242

Sunyong Chung
800 Gullett Street
Austin, TX 78702
512/389.1920

Robert Bede Clarke
103 Westridge Drive
Columbia, MO 65203
573/443.0362
Fax: 573/884.6807

Michael Cohen
Rural Route 2
Amherst, MA 01002
413/256.8691

Judith Kogod Colwell
7325 Takoma Avenue
Takoma Park, MD 20912
301/588.3634

Patrick S. Crabb
3271 Silk Tree
Tustin, CA 92780
714/731.0050

Victoria P. Crowell
376 Bald Mountain
Road
Troy, NY 12180
518/279.1105

Don Davis
67 Rice Branch Road
Asheville, NC 28804
704/251.1425

Steve Davis-
Rosenbaum
346 Sheridan Drive
Lexington, KY 40503
606/278.8335

Harris Deller
158 Madison Road
Carbondale, IL 62901
618/549.5460

Mark Derby
1122 Napoleon Avenue, #4
New Orleans, LA 70115
504/899.5960

Walter Dexter
3825 Duke Road
Victoria, BC
V924B2 Canada
250/474.2963

Jane Dillon
7947 Neva Road
Niwot, CO 80503
303/652.2691

Bob Dixon
73 Sumner Lane
Springfield, IL 62707
217/487.7743

Deanna Eckels
P.O. Box 668
Bayfield, WI 54814
715/779.3235

Leslie Eckmann
1867 Monroe Street, NW
Washington, DC 20010
202/537.6363

Bacia Edelman
1824 Vilas Avenue
Madison, WI 53711
608/257.3292

Carol B. Eder
7122 St. James Square
St. Louis, MO
63143-3527
314/781.1047

Dan Edmunds
315 North Lake
Avenue, Apt. 408
Duluth, MN 55806
218/723.4059

Len Eichler
4178 Griffin Road
Syracuse, NY 13215
315/492.0568

Susan Eisen
57 Riverview
Upper Saddle River, NJ
07458
201/327.7677

Kathy Erteman
16 E. 18th Street
New York, NY 10003
212/929.3970

Andrea Fábrega
758 Gilbert Avenue
Menlo Park, CA 94025
650/321.0259

Stephen Fabrico
Box 27
Bloomington, NY
12411
914/331.4760

Piero Fenci
Rt. 7, Box 7800
Nacogdoches, TX
75961
409/468.4495

D. Leslie Ferst
RD 2, Box 397A
Cambridge, NY 12816
518/692.7144

Marko Fields
2014 Stratford Road
Lawrence, KS 66044
785/832.1141

Dan Finnegan
106 Hanover Street
Fredericksburg, VA
22401
540/372.1466

Eve Fleck
1650 Randall Road
Yellow Springs, OH
45387
937/767.9467

Leopold L. Foulem
8625 Avenue Casgrain
Montreal, Quebec,
Canada H2P 2L1
514/382.3964

Gina Freuen
15205 N. Shady Slope
Road
Spokane, WA 99208
509/446.2973

Linda Ganstrom
206 W. 26th Street
Hays, KS 67601
785/628.8678

Nancy Gardner
1450 N. Wood Street
Chicago, IL 60622
773/489.6044

Claudette and Paul
Gerhold
PO Box 1717
Lady Lake, FL 32158
352/753.2564

John Goodheart
1104 East First Street
Bloomington, IN 47401
812/855.4395

Donna Green
124 W. 18th Street,
Apt. 6
New York, NY 10011
212/989.0595

Bill Griffith
P.O. Box 567
Gatlinburg, TN 37738
423/436.8821

Janet Harbottle
212 Oustic Avenue
Winnipeg, Mannitoba,
Canada R2M1N3
204/254.0738

Megan Hart
P.O. Box 326
192 Academy Hill
Conway, MA 01341
413/369.4949

David Calvin Heaps
P.O. Box 184
Lloyd, FL 32337
850/997.9606

Paul Heroux
P.O. Box 73
New Gloucester, ME 04260
207/926.3257

Ronalee Herrmann
P.O. Box 180
Santa Barbara, CA 93102
805/967.0323

Jennifer A. Hill
630 SW 69th Terrace, Apt. A
Gainesville, FL 32607
352/332.7376

Steven Hill
7212 Washington Street
Kansas City, MO 64114
816/523.7316

Richard Hirsch
835 Hosmer Road
Churchville, NY 14428
716/538.4048

Anna Calluori Holcombe
2034 Plymouth Road
Manhattan, KS 66503
785/587.8934

Dale Huffman
2820 Smallman Street
Pittsburgh, PA 15222
412/391.8227

Woody Hughes
3084 N. Wading River Road
Wading River, NY 11792
516/929.3418

Stanton Hunter
410 Churchill Road
Sierra Madre, CA 91024
626/355.5495

Yoshiro Ikeda
808 Wildcat Ridge
Manhattan, KS 66502
913/776.1328

Kathryn Inskeep
10992 Gold Hill Road
Boulder, CO 80302
303/459.0511

Jake Jacobson
207 E. 33 Street
Kearney, NE 68847
308/234.9881

Jared Jaffe
104 S. 13th Street,
4th Floor
Philadelphia, PA 19107
215/732.5642

Hwang Jeng-Daw
No. 20, Lane 217,
Shin-Shing Road
Tainan 802, Taiwan
886/6.265.7367

Mark Johnson
83 Romano Road
South Portland, ME 04106
207/767.7132

Don Jones
1912 Dakota NE
Albuquerque, NM 87110
505/256.0150

John Kantar
3426 St. Paul Avenue
Minneapolis, MN 55416
612/927.4890

Diane Kenney
6172 N. Bill Creek Road
Carbondale, CO 81623
970/963.2395

Bradley Keys
1332 21 Avenue, NW
Calgary, AL,
Canada T2M 1L4
403/289.3758

Joanne Kirkland
319 Koster Street
Madison, WI 53713
608/257.1510

Yvonne Kleinveld
Kerkstraat 104
Amsterdam,
The Netherlands
020/627.7868

Michael Kline
P.O. Box 614
Worthington, MA 01098
413/238.0321

Barbara Knutson
HCR 68, Box 438
Woodstock, VT 05091
802/672.5005

Malcolm E. Kucharski
110 Westfield Road
Pittsburg, KS 66762
316/231.8584

Sandra L. Lance
922 NW 39th Drive
Gainesville, FL 32605
352/372.9438

Ronald Larsen
174 County Route 35
Canton, NY 13617
315/386.4721

Les Lawrence
2097 Valley View Blvd.
El Cajon, CA 92019
619/447.6504

Emmett Leader
RR4, Box 793
Putney, VT 05346
802/387.2208

Cliff Lee
170 W. Girl Scout Road
Stevens, PA 17578
717/733.9373

Dick Lehman
1100 Chicago Avenue
Goshen, IN 46528-1941
219/534.1162

Leah Leitson
25 Delano Road
Asheville, NC 28805
704/252.2277

Mike Lemke
908 Garden Way, Apt. 12
Manhattan, KS 66502
719/565.0329

Ingrid Lilligren
1005 Gaskill Drive
Ames, IA 50014
515/294.8883

Suze Lindsay
Rt. 1, Box 164A
Fork Mountain Road
Bakersville, NC 28705
704/688.9297

Lola J. Logsdon
1441 Pikes Peak Avenue
Ft. Collins, CO 80524
970/482.2993

Janet Lowe
1117 S. 2nd Street
Philadelphia, PA 19147
215/336.3127

Sandra Luehrsen
907 W. 16th Street
Tempe, AZ 85281
602/967.6198

Peg Malloy
201 Stark Mesa Road
Carbondale, CO 81623
970/704.0862

Karen Thuesen Massaro
617 Arroyo Seco
Santa Cruz, CA 95060
408/429.5300

Berry Matthews
72 Court Street, #1
Plattsburgh, NY 12901
518/561.4938

George McCauley
506 W. Lawrence
Helena, MT 59601
406/449.3087

Donna McGee
84 Elm Street
Hatfield, MA 01038
413/584.0508

Paul A. Menchhofer
131 Marietta Circle
Oak Ridge, TN 37830
423/691.7794

Hilda Merom
9 Rotem Street, P.O. Box 62
Kefar Veradim, Israel 25147
972/49976998

Mark Messenger
5129 Heavenly Ridge
El Sobrante, CA 94803
510/685.1230

Richard Milette
8625 Avenue Casgrain
Montreal, Quebec, Canada
H2P 2L1
514/382.3964

Lori Mills
550 Holley Street
Brockport, NY 14420
716/637.9394

Nicolette Mitchell
930 Bertrand #1
Manhattan, KS 66502
785/537.7179

Hideaki Miyamura
30 Mineral Street
Ipswich, MA 01938
508/356.7016

Una Mjurka
1266 Shasta Avenue
San Jose, CA 95126-2636
408/297.4858

Jerod Morris
840 Dondee
Manhattan, KS 66502
785/537.7897

Jane Morse
304 Nettleton Hollow Road
Washington, CT
860/868.2900

Judi Motzkin
7 Tufts Street
Cambridge, MA 02139
617/547.5513

Kevin A. Myers
415 East Dryden
Glendale, CA 91207
818/242.5579

Ragnar Naess
107 Hall Street
Brooklyn, NY 11205
718/636.8608

Hiroshi Nakayama
Fisk Road
Worthington, MA 01098
413/238.0465

Charles B. Nalle
P.O. Box 510058
Melbourn Beach, FL 32951
407/729.0816

Mika Negishi
2035 Tecumseh Road
Manhattan, KS 66502
785/776.3724

Eric Nelson
10923 SW 239 Street
Vashon, WA 98070
206/463.2062

Shannon Nelson
P. O. Box 61468
Fairbanks, AK 99706

Alan and Brenda Newman
4308 Riverdale Road South
Salem, OR 97302-9718
503/371.8202

Mary T. Nicholson
933 Haverstraw Road
Suffern, NY 10901
914/354.1049

Susan O'Brien
2541 Oleander
Baton Rouge, LA
504/343.3567

Jeff Oestreich
36835 Pottery Tr.
Taylors Falls, MN 55084
612/583.2532

Laney K. Oxman
Rt. 9, Hillrose Cottage
Hillsboro, VA 20134-1515
703/478.8196

Francine Ozereko
5 Amherst Road
Pelham, MA 01002
413/253.2664

Frank Ozereko
5 Amherst Road
Pelham, MA 01002
413/253.2664

Marie J. Palluotto
5 Glenview Terrace
Maynard, MA 01754
508/897.3192

Neil Patterson
2545 Meredith Street
Philadelphia, PA 19130
215/763.8439

Greg Payce
1408 11 Avenue, SE
Calgary, AB, Canada
T2G 028
403/237.7845

Sandi Pierantozzi
2545 Meredith Street
Philadelphia, PA 19130
215/763.8439

Grace Pilato / Ian
Stainton
524 S. Allen Street
State College, PA 16801
814/238.5828

Frank Pitcher
RR 1, Box 436
Deer Isle, ME 04627
207/348.2322

Paulien Ploeger
Oude Bildtdijk 732
9079 NB St. Jacobiparochie
The Netherlands
0518 402277

Hunt Prothro
Box 61
Rohrersville, MD 21779
301/432.2941

Elsa Rady
1500 Andalusia Avenue
Venice, CA 90291
310/396.6063

Claudia Reese
709 N. Tumbleweed Trail
Austin, TX 78733
512/263.5018

Thomas Rohr
4-124 16th Avenue NW
Calgary, AB, Canada
T2M0H2
403/276.2633

Elizabeth Roman
Feat of Clay
P.O. Box 161
East Calais, VT 05650
802/456.1612

Paul Rozman
106 3219-56 Street, NE
Calgary, AB, Canada TIY 3R3
403/590.0090

Harvey Sadow
9540 Quail Trail
Jupiter, FL 33478
561/744.2209

Judith Salomon
3448 Lynnfield Road
Cleveland, OH 44122
216/751.4794

Steffanie Samuels
829 Tappan #004
Ann Arbor, MI 48104
313/668.6360

Anne Schiesel-Harris
PO Box 275
Westpark, NY 12493
914/384.6396

Brad Schwieger
13350 Scatter Ridge Road
Athens, OH 45701
614/593.3500

Barbara Sebastian
1777 Yosemite Avenue
Suite 4B-1
San Francisco, CA 94124
415/822.3243

Bonnie Seeman
9433 Chelsea Drive South
Plantation, FL 33324
305/284.5470

Kathryn Sharbaugh
4304 Grange Hall Road
Holly, MI 48442
248/634.3603

Peter Shire
1850 Echo Park Avenue
Los Angeles, CA 90026
213/662.8067

Susan Sipos
111 Dawson Street, Rear
Philadelphia, PA
19127- 1803
215/482.5681

Gertrude Smith
644 Cane Creek Road
Bakersville, NC 28705
704/688.3686

Chuck Solberg
1688 Randolph
St. Paul, MN 55105
612/699.7322

Farraday Newsome Sredl
12801 N. 25th Avenue
Phoenix, AZ 85029
602/371.1619

David Stabley
Rd. #3, Box 18A,
Fisher Run Road
Bloomsburg, PA 17815
717/784.8606

Ian Stainton
Box 105A, Rt. 1
Spring Mills, PA 16875
814/364.9974

Chris Staley
210 Patterson
Penn State University, PA
16802
814/865.6412

Bill Stewart
2489 Roosevelt Highway
Hamlin, NY 14464
716/964.2325

Alfred Stolken
P.O. Box 180
Santa Barbara, CA 93102
805/967.0323

Vincent Suez
925 Brent Circle
Placentia, CA 92870
714/579.0626

Richard Swanson
585 S. Rodney
Helena, MT 59601
406/442.8106

Marvin Sweet
11 Heath Road
Merrimac, MA 01860
978/346.4268

Sam Taylor
35 Perry Hill Road Ext.
Westhampton, MA 01027
413/527.4410

Billie Jean Theide
317 Elmwood Drive
Champaign, IL 61821-3218
217/398.1956

Joseph A. Triplo
4320 US Highway 209
Stone Ridge, NY 12484
914/687.4932

Ann M. Tubbs
P.O. Box 208
Ottawa Lake, MI 49267
313/856.1859

Patrick Tuddy
2035 Tecumseh Road
Manhattan, KS 66502
785/776.3724

Eric Van Eimeren
504 W. Lawrence
Helena, MT 59601
406/443.6359

Rimas VisGirda
317 Elmwood Drive
Champaign, IL 61821-3218
217/398.1956

Ted Vogel
4016 SE Brooklyn
Portland, OR 97202

Barbara Walch
RR 1, Box 880
Thorndike, ME 04986
207/568.3736

James C. Watkins
3017 28th Street
Lubbock, TX 79410
806/792.6247

Stan Welsh, Margitta
Dietrick
4693 Branciforte Drive
Santa Cruz, CA 95065
408/429.9365

Geoffrey Wheeler
2010 Park Avenue S., #301
Minneapolis, MN 55404
612/874.7272

Catherine White
7908 Cannonball Gate Road
Warrenton, VA 20186
540/347.3526

Laura Wilensky
679 Lapla Road
Kingston, NY 12401-7747
914/338.2199

Lana Wilson
465 Hidden Pines Lane
Del Mar, CA 92014
619/755.3940

Matt Wilt
113 Fairmount Avenue
Philadelphia, PA 19123
215/238.0906

Bruce M. Winn
669 Elmwood Avenue
Providence, RI 02907
860/567.4788

Kate Winn
3084 N. Wading River Road
Wading River, NY 11792
516/929.3418

Robert Winokur
435 Norristown Road
Horsham, PA 19044
215/675.7708

Robert Woo
122 West Pelham Road
Shutesbury, MA 01072
413/259.1239

Robert L. Wood
135 Stillwell Avenue
Kenmore, NY 14217
716/873.5895

Erica Wurtz
26 Parsons Road
Conway, MA 01341
413/369.4006

Rosalie Wynkoop
2915 Country Club Avenue
Helena, MT 59602
406/443.4664

Minako Yamane-Lee
12999 Via Grimaldi
Del Mar, CA 92014
619/755.7140

Sybille Zeldin
200 Delancy Street
Philadelphia, PA 19016
215/922.1975

INDEX